33
Keys
to Unlocking
The Lost Symbol

33
Keys
to Unlocking
The Lost Symbol

A Reader's Companion
to the Dan Brown Novel

Thomas R. Beyer, Jr.

Newmarket Press • New York

This book is published in the United States of America.

FIRST EDITION

Library of Congress Cataloging-in-Publication
Data Available Upon Request

ISBN 978-1-55704-919-3

QUANTITY PURCHASES
Companies, professional groups, clubs, and other organizations may qualify for special terms when ordering quantities of this title. For information, e-mail sales@newmarketpress.com or write to Special Sales, Newmarket Press, 18 East 48th Street, New York, NY 10017; call (212) 832-3575 ext. 19 or 1-800-669-3903; fax (212) 832-3629.

Manufactured in the United States of America.

www.newmarketpress.com

Dedication

I	E	A	L	E	X
N	E	A	C	A	A
A	H	D	O	R	N
F	T	O	R	I	D
E	T	S	A	N	R
R	E	Y	E	B	A

CONTENTS

Introduction

Dan Brown's long-awaited, new novel, *The Lost Symbol*, has finally arrived. "All will be revealed," as the pre-publication publicity proclaimed. Readers who have waited patiently have welcomed back the now familiar hero, Robert Langdon. Eighty million copies of *The Da Vinci Code* have been sold worldwide, and millions of viewers have seen the movie or the 2009 *Angels & Demons* film. The fictional professor has already achieved cult status among adults, reminiscent of the earlier success of James Bond in the Ian Fleming novels and countless movies since *Doctor No* with Sean Connery and Ursula Andress. The new novel has liberal references and allusions to the earlier adventures of Langdon in Rome and Paris, reinforcing from time to time our recollections of those works. Those two previous novels, in what now appears to be a series, establish a foundation and a context for what will come.

We have come to expect that Langdon will be summoned from Cambridge to some gruesome crime scene in a major metropolis. The murderer or assassin will be a horrific figure, the incarnation of evil itself. Langdon will be joined by a brilliant woman who is the victim of a family tragedy. Together they will set out on a breathtaking, page-

turning quest in search of answers. Along the way Langdon will call upon his extensive knowledge of ancient symbols and religions and his familiarity with art and architecture to follow clues and unravel ciphers to recreate a roadmap leading to some lost wisdom.

This time *The Lost Symbol* takes us on a whirlwind, one-night adventure of Robert Langdon, who rushes through Washington, D.C., in an effort to save his friend, Peter Solomon, a 33rd-degree Mason. On his own abbreviated odyssey, Langdon encounters the secrets of our nation's capital and its origins and design. All the while he is speeding through a series of historical buildings, from the U.S. Capitol to the Masonic House of the Temple, culminating at the Washington Monument. The city serves as the perfect setting for a C.I.A. cover-up and Dan Brown's ongoing attempt to reconcile the clash of science and spirituality. *The Lost Symbol* unveils some of the secrets of the Freemasons and the Judeo-Christian Biblical tradition to reveal their "synchronicity of beliefs." These beliefs, we will learn, emanate from the Ancient Mysteries that have all along held the key to the Lost Word that was right before our eyes, yet nevertheless invisible.

Langdon, as his readers know, is a teacher, as was Brown before his career as a writer. Langdon cautions us of the enormity of the task: "To understand the Ancient Mysteries is a lifelong process" (486)*. As for any good teacher his aim is to arouse an intellectual curiosity, to raise questions, for true wisdom begins with a recognition that life is a continuous search for answers. Peter Solomon, in a comment that could well be applied to the entire Langdon series, admits: "I now realize that the Masonic Pyramid's true purpose was not to reveal the answers, but rather to

*Page numbers for *The Last Symbol* are indicated in parentheses.

inspire a fascination with them" (494). In this regard the novel succeeds magnificently.

The novel is also one gigantic puzzle. The novel had been anticipated ever since Brown left a series of clues and teasers on the dustcover of his enormously popular *The Da Vinci Code,* and voiced his intention to write a novel centered in Washington, D.C., involving America's secret society, the Freemasons. The inside dustcover commentary for *The Da Vinci Code* (2003) contained a series of letters in boldface that when pieced together read: "Is there no help for the widow's son." Brown himself stated on one occasion that he was working on another novel involving his hero, Robert Langdon, that would be "set deep inside . . . the enigmatic brotherhood of the Masons." The original working title was *The Solomon Key*, revealed by Brown's publisher, Stephen Rubin, as early as 2004.

The novel itself was preceded by a carefully crafted and somewhat enigmatic publicity campaign. In April 2009 a prepublication announcement by Doubleday noted that a printing of five million was being prepared for the release date of September 15. That publication date, September 15, 2009, was reputed to have a significance that would be obvious upon reading the novel. (The solution is 09/15/09 = 9+15+9 = 33, a number that appears on the cover of the American edition). The announcement preceded by just a few weeks the May 2009 release of the motion picture *Angels & Demons,* directed by Ron Howard and starring Tom Hanks. In July 2009, Doubleday continued the prepublication campaign by posting a website with a widget and countdown clock to September 15. There was also an invitation to sign up for news announcements, as well as links to Facebook and Twitter accounts devoted to the novel. Over 100 clues appeared first on Facebook and Twitter that included ciphers, images, and statements, all of which gen-

erated sometimes extensive commentary. Facebook had over 90,000 friends with a teaser that appeared from time to time claiming "Dan Brown's publisher will announce the name of Robert Langdon's next adversary when we reach 100,000 fans." In August a high-quality PDF file of the cover art was made available for downloading. Like its predecessor the dustcover holds hidden secret messages for closer scrutiny. Dan Brown's homepage underwent redesign. The site features a bookshelf and also contain an "Easter egg." By clicking on a picture in the lower right-hand corner that resembles a scene from *The Apotheosis*, the picture transforms into one of the author Dan Brown and opens a secret compartment. This compartment in turn can be opened to reveal the entire set of puzzles associated with all the Dan Brown novels, including one for *The Lost Symbol*. One week before the novel's publication a "Symbol Quest" was posted, promising: "If you successfully master SYMBOL QUEST and ascend perfectly, a rewarding message awaits you!" There is already a *Lost Symbol Memory Game* for the iPhone.

 The Lost Symbol has scores of historical figures and places, titles, citations, word games, details, and "Facts." Langdon is an avid swimmer, who works out in the early morning at 4:45 AM on a Sunday in Harvard's Blodgett Pool. (But the pool is open early mornings only for age-specific groups, not for individual swimming—just one little stretching of the facts.) Separating fact from fiction is the overriding demand upon Brown's readers. The author himself invites the scrutiny. In *Angels & Demons* he had simply declared as "Fact" the existence of CERN and of antimatter. In his "Author's Note" he assured us:

References to all works of art, tombs, tunnels, and architecture in Rome are entirely factual (as are their exact

locations). They can still be seen today. The brotherhood of the Illuminati is also factual.

In *The Da Vinci Code* he states as "Fact" the existence of the Priory of Sion and Opus Dei. Brown delights in daring to obscure the traditional boundaries of fiction and the real world. In *The Lost Symbol* we are confronted with another page of "Facts": a 1991 document locked in a safe of the CIA, whose cryptic text contains the phrase "*It's buried out there somewhere.*" Or "All organizations in this novel exist." This is a far cry from claiming that everything to be revealed about the Freemasons, the Invisible College, the Office of Security, the SMSC, and the Institute of Noetic Sciences is true. But uninitiated or unwary readers may extend the carefully phrased claims into something more sinister. The "Fact" sheet concludes: "All rituals, science, artwork, and the monuments in this novel are real." To state that something is "real" is hardly a revelation, but even this statement, as we shall see, needs some qualification.

Notwithstanding Brown's assertions that precede the action of his novel, the copyright page clearly states: "This book is a work of fiction." Dan Brown is a writer; his goal is to entertain and perhaps inform his readers. His talent and artistic ability are to transport us to exciting locales, unlock doors to unknown secrets, open our eyes to familiar images, and revisit history. His novels have driven readers to explore on their own the places, artworks, architecture, and geography that they encounter. To a large degree the overwhelming popularity and success of his works worldwide are due to this stimulation of reader curiosity.

I am one of those curious readers, in search of the facts behind the fiction. This book is a journey by way of *33 Keys* to the novel. What is the reality; where is the fiction? Brown spent years researching the book and fills his pages

with an extraordinary amount of information. To explore it all could take months, if not years, even for those who carry their Blackberries or laptop computers connected to the Internet. There are dozens, hundreds, and in the case of the Masons and conspiracy theories, literally thousands of websites, and their pages can be multiplied tenfold. Brown almost anticipates the search when he has Langdon admonish his students that "'Google' is not a synonym for 'research'" (98). No it isn't, but from the director of the CIA Office of Security to Katherine Solomon and her assistant, all use Internet search engines to gather relevant and valuable information.

The Lost Symbol is its own quest, a journey in search of something lost, the discovery of which should illuminate the finder and provide entry into an exclusive esoteric group to whom the Word has been revealed. At the end Robert Langdon paraphrases the Gospel of Luke 8:17: *"Nothing is hidden that will not be made known; nothing is secret that will not come to light"* (508). The novel is a treasure trove of hidden or little-known facts. Be prepared to learn a little and then explore more on your own by following the 133 helpful links. "Google" whatever arouses your curiosity. Join with those for whom the Mysteries are just the beginning of a lifelong journey!

Let this book be your companion and guide to making the novel come into clearer perspective, to shine a light on some of its mysteries and myths, and unlock a few of the hidden secrets in search of the Symbol become Word, to create some "Order out of Chaos." If you enjoyed Dan Brown's *The Lost Symbol* the first time, you'll know lots more and enjoy the novel even more as you recall episodes, or maybe even reread the entire book.

Links:

The Lost Symbol
www.thelostsymbol.com

Dan Brown homepage
www.danbrown.com

Dan Brown on Facebook
www.facebook.com/DanBrown

Dan Brown on Twitter
twitter.com/lostsymbolbook

I.
NAMES AND GAMES
>⊓□⌐ ⌐∨ >∨ ← ⊐∪⌐ ⌐

There are almost two dozen major and minor characters in *The Lost Symbol*, where over the course of one Sunday night in January the plot unfolds primarily in Washington, D.C. It is a circular journey, like an ouroboros, the symbol of a snake biting its own tail to form a circle, that brings us back to the U.S. Capitol to behold dawn's early light and with it the illumination, or enlightenment, that was there all the time. Dan Brown loves words and names, their history, their associations, their concealed meanings. Names in particular can evoke curious associations. Some are anagrams, a play on words where the letters can be rearranged to reveal another name or phrase. In *The Da Vinci Code,* the character Leigh Teabing points to Baigent and Leigh, the authors of *Holy Blood, Holy Grail*, who later would accuse Brown in a London court of plagiarism. In selecting the occult number of 33, I have made choices and so many of the characters' names that still may have secrets to share have been omitted. Who knows what other lost words might be uncovered by readers when they have reread and then reexamined the book?

Robert Langdon

Langdon is back, having survived sure death at the hands of assassins in *Angels & Demons* in 2000 and *The Da Vinci Code* in 2003, as well as in the movies, where he is portrayed by Tom Hanks. Langdon is a bit wiser and more modest, and we, the reader, learn somewhat more about him. But in *The Lost Symbol*, Langdon still always knows things a few minutes or a few chapters before he tells us.

Langdon is a forty-six-year-old professor of religious symbology at Harvard University in Cambridge, Massachusetts. The Harvard website lists no such professor, no such discipline, and no personal webpage. So Langdon created his own. This personal webpage for a character in a novel, along with a photograph of his masked fictitious editor, J. Faukman (an anagram for Brown's actual editor Jason Kaufman), was all part of a virtual reality support system for fiction. Created for *The Da Vinci Code*, Robert's homepage is a twenty-first-century hoax. A similar sleight of hand is an actual webpage for the nonexistent Depository Bank of Zurich in that novel. The fictional bank comes with its own fictional history. There is even a possibility to log in if you have the account name and number (try the Fibonacci

sequence). All of this is great fun for some, but it runs the risk of calling into question the boundary between reality and virtual reality that has become a trademark of Robert Langdon and Dan Brown.

Langdon may now be famous for his exploits in Rome and Paris, for in the opening pages of this novel Pam from Passenger Services at Dulles Airport recognizes him. But fame has not altered his clothing that is far less fashionable than Tom Hank's custom-made Brioni suit for *Angels & Demons*. His "uniform" is a charcoal turtleneck, Harris tweed jacket, khakis, and loafers. Dan Brown and Robert Langdon have at least this much in common if one is to judge by a widely used publicity photo available from their publisher. Langdon attended Philip Exeter Academy, where Brown both studied and later taught English. Langdon is a Princeton University graduate, where he also competed in water polo, which explains why he is an avid swimmer, who enjoys early morning workouts. Because of a childhood accident that left him at the bottom of a well for a night, he is terribly claustrophobic, and so confined spaces give him and the reader serious heart palpations. Langdon first appears in his own dream of a claustrophobic ride in an elevator on the Eiffel Tower. The Parisian landmark is not only the structure that surpassed the Washington Monument when it was opened in 1889, but it also serves as a reminder of the city setting for *The Da Vinci Code*. Langdon's need for *light* in his nightmare is also a perfect introduction to the theme of Masonry and the Masonic rituals that offer enlightenment.

The name Langdon is taken from John Langdon, the artist who provided the stunning ambigrams for *Angels & Demons,* those words which when rotated 180 degrees are the same upside down as right side up. Brown acknowledged his debt to John Langdon for the ambigrams and the name

in his London court appearance, where he was being sued for alleged plagiarism.

> As a tribute to John Langdon, I named the protagonist Robert Langdon. I thought it was a fantastic name. It sounds very "New England" and I like last names with two syllables (Becker, Langdon, Sexton, Vetra, et al). Every character has his purpose, and with Langdon I wanted to create a teacher.

There was also a famous John Langdon (1741–1819) from New Hampshire, Brown's home state, one of the first United States senators and later its governor.

Langdon is indeed a teacher, and his classes at Harvard are well attended as he mesmerizes students with his command of the esoteric and occult theories. But he is also careful to dismiss many claims and statements on the Internet as having no foundation. As a professor he has recognized, as has Brown, the added responsibility when one is held by the general public to higher standards. Some reviewers of *The Lost Symbol* remarked that Langdon is nowhere as critical of the institution of Freemasonry as he had been of the Catholic Church, which felt misrepresented by Brown's earlier blends of fact and fiction. This new, more objective, thoughtful, and balanced approach may simply be the result of a heightened self-awareness that Brown himself remarked on:

> I was already writing *The Lost Symbol* when I started to realize *The Da Vinci Code* would be big. The thing that happened to me, and must happen to any writer who's had success, is that I temporarily became very self-aware. Instead of writing and saying, "This is what the character does," you say, "Wait, millions of people are going to read this." It's sort of like a tennis player who

thinks too hard about a stroke—you're temporarily crippled.

The concept of teaching is a recurring theme for *The Lost Symbol*, for the secret wisdom is passed from generation to generation. Brown in the same trial statement underlined the aspect of father as educator, the one who leads us. He humbly recognized his debt to his father: "Many of the people I admire most are teachers—my father is the obvious figure from my own life. . . . John Langdon is also a teacher." In the novel Langdon will be both teacher and student, who in trying to save Peter Solomon's "soul" will undergo his own transformation.

Links:

ROBERT LANGDON WEBSITE
www.randomhouse.com/doubleday/davinci/robertlangdon

DEPOSITORY BANK OF ZURICH
www.randomhouse.com/cgi-bin/robertlangdon/dbz.cgi

JOHN LANGDON
www.johnlangdon.net/ambigrams

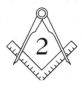

Mal'akh, Christopher Abaddon, Zachary

Mal'akh, the dark, tattooed, shadowy figure, is certainly the equal of Langdon's past nemeses, as cold-blooded as Hassassin in *Angels & Demons* and Silas in *The Da Vinci Code*. He is a man of many names and many faces, a master of deception, a conjuror who will come, as does the novel, full circle in the course of the evening. We first encounter "The one who called himself Mal'akh" (10). This is an assumed name that comes from מַלְאָךְ (*mal'ach*/mal'akh), the Hebrew word for "angel" and sometimes "messenger." Hassasin in *Angels & Demons* will refer to himself as "Malak al-haq—the Angel of Truth." But this figure is a fallen angel, a demon, the Moloch of *Paradise Lost* and the Book of Leviticus. The transformation of names by Mal'akh is graphically depicted on his tattooed body, which is supposed to reflect the hidden, inner truth. But when his body is exposed to the light, the truth is visible to all. As one mortal man had shouted: "Good God, you are a demon" (12). In public, Mal'akh masquerades as Dr. Christopher Abaddon. The two names are an ironic combination of Christopher the "Christ bearer" and the Abaddon of St. John's

Revelations 9:11: "And they had a king over them, which is the angel of the bottomless pit, whose name in the Hebrew tongue is Abaddon." The Book of Revelations is more commonly known as *The Apocalypse*, often interpreted as the ending of the world, but from the Greek word meaning "lifting of the veil." Mal'akh's oft-repeated refrain "The secret is how to die" echoes Revelations 9:6: "And in those days shall men seek death, and shall not find it; and shall desire to die, and death shall flee from them."

The demon also calls himself Anthony Jelbart, the secretary of Peter Solomon, on the phone to Langdon. Mal'akh had also lived for a time under the alias of Andros Dareios, which he explains as *"Andros* meaning 'warrior,' and *Dareios* meaning 'wealthy.'" (223). In truth, all of these are assumed identities for Zachary Solomon, the prodigal son of Peter. In the New Testament, Zachary was the father of John the Baptist, the cousin of Jesus, His messenger, who

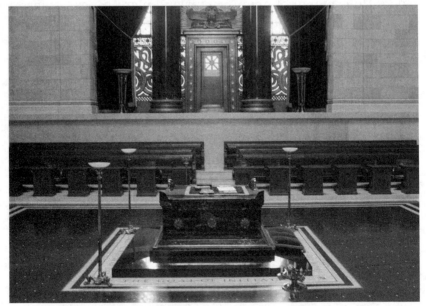

©AFP/Getty Images. Photo by Tim Sloan.

The Temple Room in Washington, D.C.

eventually had his head chopped off. In the Old Testament of the Bible there is the closely related Zechariah, the Hebrew name meaning "Yahweh had remembered." The name also points to the Book of Zechariah 6 and 7, which introduce the concept of the Four Horsemen, foreshadowing the Apocalypse.

It almost appears as if Zachary has risen from the dead, for during most of the novel he is presumed to have died. He has actually endured two near deaths, the first in prison and the second at the Solomon household robbery attempt. He appears for the third time to reclaim the secret pyramid he had rejected as his birthright on his eighteenth birthday. A profligate life had landed him in a Turkish jail, where his father, Peter, apparently sacrifices him to teach him a lesson. In a transformative act Zachary will become a new man *(andros)*. He pursues a hedonistic existence, but it is replaced by an urge to gain not only wealth, but wisdom too. His thwarted attempt to steal the Masonic Pyramid results in his killing his grandmother, and then being wounded by her and by his own father. He begins his own scholarly search for meaning, not unlike Manly P. Hall, the chronicler of the Secret Mysteries. He returns to Washington, believing the promise of the 33rd degree of the Scottish Rite of Freemasons that "all will be revealed." When the degree is conferred without the requisite wisdom, Mal'akh plots to extract the secret from his father and transform himself. He also intends to destroy the work of his aunt, Katherine. Mal'akh seeks not light, however, but rather to plunge the world into darkness, "to obscure the light" (54). His study had brought him to emulate the black magic of Aleister Crowley, known to many a century ago as the "wickedest man in the world." Through his fasting and satanic ritualistic preparation, Mal'akh attempts to replicate in diabolical fashion the story of Abraham and Isaac, the father who was

asked to sacrifice his own son. This is known as the Akedah in the Book of Genesis 22. Mal'akh/Zachary will be frustrated to the end. He will not die at his father's hand, but he will nevertheless be sacrificed upon the altar of the House of the Temple. There in the Temple Room, outlined in a circle, like the bare circle upon his head, he forms a human circumpunct, symbolizing the one God.

Links:
THE CONFESSIONS BY ALEISTER CROWLEY
www.hermetic.com/crowley/confess/chapter1.html

Peter, Katherine, Isabel Solomon

The key to understanding the character of Peter is the Gospel of Matthew 16:17-19, in which Jesus renames Simon Peter. Christ promises to build upon the rock His church, and grants Peter the keys to the kingdom of heaven. Peter *(petros)* in Greek thus becomes the foundation or rock *(petra)* of Roman Catholicism. The multiple associations to the Papacy and St. Peter's Basilica and Square in Rome are obvious and all central to *Angels & Demons*. The Solomon surname recalls the Son of David, the wise king, the builder of the temple (1 Kings). Solomon is also a central figure for the Knights Templar and Masonic legends and appears in many of the occult texts of Europe, including the *Key of Solomon*. Nor should one forget that *The Lost Symbol* was originally conceived as *The Solomon Key*.

Peter is a 58-year-old "philanthropist, historian, scientist," a graduate of Yale, who traces his family back to the Royal Society of London, the offspring of "The Invisible College." The multi-millionaire Secretary of the Smithsonian Institute and Supreme Worshipful Master of the Scottish Rite Southern Branch of the Freemasons, Peter has suffered great losses. He has witnessed, and is to some extent responsible for, the death of his mother, and he

assumes for the death of his son, Zachary. Peter is like a father to Robert Langdon, who had heard him lecture at Princeton and then at Philips Exeter. Peter offers several of his own mini-lectures in the novel, including one on Deists and the Founding Fathers. He also exhorts the students to read the Bible.

Peter has been entrusted with a secret package passed down through generations of Solomons and Freemasons, which he gives to Langdon for safekeeping. He will also become the figurative and literal guide for the initiate Robert Langdon to Masonic teachings. In imitation of the first degree Masonic initiation ritual, Peter will blindfold

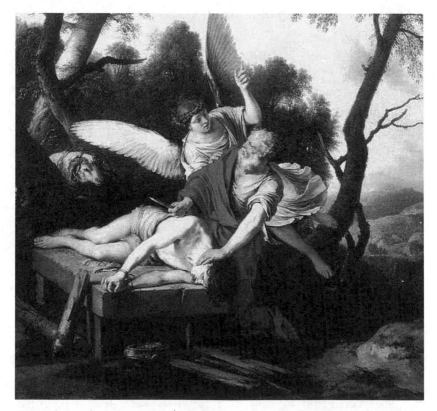

Sacrifice of Isaac, painting by Laurent de La Hyre (1650)

and lead Langdon to the Washington Monument, where he unveils the message of "Praise be to God." There buried in the cornerstone is the Masonic Bible, the Lost Word. Peter does not deny, but accepts the legend of the Ancient Mysteries that hold a *"key,"* a *"password,"* the *"verbum significatium"* (408). He is simultaneously the figure of Abraham, ready to sacrifice his son, and a long-suffering Job, who has lost mother, wife, and son. He is a mutilated and tortured father figure of biblical proportions, but he is also without his right hand. He suffers mental and physical indignities at the hands of Mal'akh, but like Abraham, Peter is saved from sacrificing his son with the Akedah knife.

Oh, and Peter's telephone number actually works: 202-329-5746. The number is listed in the text, and true Dan Brown fans will certainly recognize that it doesn't contain the usual 555 prefix for fictional telephone numbers. Call and see if you can find Peter at home!

Katherine Solomon is Langdon's female companion in his search. Katherine in the Christian tradition signifies "purity," but has its origins in the Greek, where it is related to the word "catharsis," an emotional cleansing. She is a fifty-year-old scientist, researcher, and author of *Noetic Science: Modern Gateway to Ancient Wisdom.* Her book does not exist, but it calls to mind two titles: *The Secret Gateway: Modern Theosophy and the Ancient Wisdom Tradition* and *Ancient Wisdom and Modern Science.* Katherine may have real-life counterparts: Lynne McTaggart, actually cited in the novel for her work on *The Intention Experiment,* and Marilyn Schlitz of the Institute of Noetic Sciences in California. Katherine is more than Langdon's companion; she is also the one who unveils the golden pyramid by unwrapping the sealed package her brother had given Robert. This in turn launches the quest to decipher the clues on the Masonic Pyramid.

Katherine's and Peter's mother, Isabel, appears only briefly, but is the grandmother killed by Zachary in a patricide gone astray. The name means "God's vow or promise." Isabel fires the shotgun that mutilates the intruder, who is actually her grandson. She is accidentally murdered by him, and were there a good English word to describe the killing of one's grandmother, Brown would surely have used it. Nonetheless this has all the elements of a Greek tragedy in the making.

Links:

THE KEY OF SOLOMON
www.esotericarchives.com/solomon/ksol.htm

Word Games

"*In the beginning was the Word.*" (489). Dan Brown loves italics but he doesn't provide the quotation marks that would identify this as a quote from the Gospel of John 1:1 that continues: "and the Word was with God, and the Word was God." *The Lost Symbol* is the Lost Word and that word is a symbol. Brown and Langdon have a reverence and respect for words. All words can potentially take on special significance in this novel that revolves in circular fashion around The Word. The result is a circumpunct, a circle around a dot and symbol of the Deity. One of the author's favorite pastimes is the discovery of the etymology, or the original meaning, of a word. For the ancients this root, ετυμον (etumon), "true sense," explains the belief that if one could find the origin of a word, what it meant at first utterance, then one would be able to identify the real true meaning, even if it had been "lost" with time.

Langdon provides a running etymological commentary to several words in the book:

Apotheosis: "ancient Greek: *apo* – 'to become,' *theos* – 'god.'" . . . *Apotheosis* means 'to become God'?" (84).

Cravat: "derived from a ruthless band of 'Croat' merce-
naries who donned knotted neckerchiefs before they
stormed into battle." (8).

Sacrifice: *"Sacra*—sacred. *Face*—make." *"Make yourself
sacred."* (287).

Talisman: "Greek *telesma*, meaning *'complete.'"
(167).*

Word games and puzzles are frequently used to lead
or mislead the unsuspecting. Langdon will eventually have
to rearrange the 64 symbols found on the Masonic Pyramid.
The third line of the 64-block word square [see page 429 of
novel] reads: L Au S (pyramid) D E (ouroboros)—the snake
biting its tail which also resembles the capital letter O. The
line can be interpreted in a number of ways. Literally, or
more precisely graphically, we are presented with the stone-
mason's square, the scientific abbreviation for gold, the
Greek letter sigma used in math for the "sum," the Greek
letter delta, used in math for "change," the alchemical sym-
bol for mercury, and the ouroboros. But there is another lit-
eral level, the symbols as letters that we as readers have
almost forgotten to see. Because right before our eyes is the
phrase LAUS DEO, "Praise to God." The goal of the entire
journey is the revelation related to The Lost Word.

The author through his characters attempts to fore-
warn the reader: "Language can be very adept at hiding the
truth" (196). The novel contains numerous instances that
could haunt writers and readers. The enigmatic IIIX88S is
actually SBBXIII, indicating a subbasement room 13 in the
belly of the Capitol building. Misspellings of the San Greal or
the Holy Grail, we are told in *The Da Vinci Code,* lead to the
understanding of Sang Real as meaning Holy blood.
Mistranslations from the Book of Exodus by St. Jerome have

given us a Moses with "horns." Letters can be substituted for numbers. Gematria in the Kabbalah assigned numerical values to letters in the Bible seeking still unrevealed messages. Perhaps it is pure coincidence that *The Solomon Key,* now *The Lost Symbol*, both contain thirteen letters?

Ever the teacher, Langdon explains some words to his Harvard students and us: "the word *occult,* despite conjuring images of devil worship, actually means 'hidden' or 'obscured'" (27). We are reminded to look carefully at words to see how "atonement" can become "at-one-ment" and "revelations" can be "revealed." Beware of puns! Langdon comments that Noetic science is "all Greek to me" and it is later identified as coming from the Greek "*nous,*" "inner knowing," a kind of intuitive consciousness. Readers need to know Latin to translate "Tempus fugit." Brown also hopes you will use a good dictionary to identify his "coelacanth" and "Architeuthis squid."

This is an ongoing quest. Even the dustcover conceals letters and numbers that ultimately yield a New York City telephone number! I am convinced that more will come out as you search for your own associations and connections. Not only was the word in the beginning, but *The Lost Symbol* is the beginning of word games that are likely to see ever more secrets unraveled by true believers in search of that Holy Grail of Enlightenment.

Links:
Etymological dictionary online
www.etymonline.com

II.
THE DISTRICT OF COLUMBIA
> ⊓◻⊾ ⊏∨ >∨ < ⊐⊔⊏ ⊾

From the Rome and Vatican City of *Angels & Demons* to the Paris of *The Da Vinci Code*, Dan Brown brings Americans to tour their capital, Washington, D.C. (District of Columbia). This was the intention all along, as Brown himself had revealed in an interview. Many of those who anticipated the work began rediscovering the architecture, the monuments and public buildings, and the symbols strewn throughout the capital and its Capitol Building that grace the American edition dustcover. (Even Americans at times confuse "capital" which is from the Latin word "capitalis," meaning chief and, in this case, the seat of government, and the Capitol, from Latin "Capitolium," the temple of Jupiter at Rome on the Capitoline hill).

Most Americans will be familiar with some of these places, although fewer will have seen and been through the new U. S Capitol Visitors Center, just opened in 2008. The Center provides access to the Capitol itself, where the two branches of the U.S. Congress, the House of Representatives and the Senate, carry out their work of legislating. While visitors to the city cannot possibly avoid the sight of the Washington Monument even from a distance, far fewer

have risen to its magnificent observation deck. Other places in Washington mentioned in the novel may be less familiar, as Robert Langdon and Katherine Solomon rush from place to place. They escape the basement of the Capitol through underground passages to the Library of Congress (yes, they do exist). There is also a transportation system that Senators and Representatives use to travel to their respective offices, now located in separate buildings. The National Art Gallery, home to the engraving by Albrecht Dürer, is mentioned, but Katherine and Robert with no time to spare will use a computer to access a digital print. The triangular pyramids in the courtyard of the Gallery are never brought to light. The U. S Botanic Garden, located to the southwest of the Capitol, also makes a brief appearance, but the action quickly moves to the National Cathedral and then to the House of the Temple on 16th Street. The Temple is just a few hundred yards north of arguably the most famous building in Washington, the White House, which serves as residence and office of the President of the United States. Ultimately the novel brings us back to the Washington Monument and then to the Capitol in the completion of a circle through the city. Katherine and Peter never get outside the District to Virginia, where the headquarters of the Central Intelligence Agency (CIA) is located. But its operatives are hard at work and the Director of its Office of Security appears miraculously at the Capitol. The Office's existence is mentioned as a "Fact." It is not all that secret for a recent employment opportunity listed on the Internet described its functions: "The Office of Security supports the CIA's mission by providing a comprehensive, worldwide security program that protects CIA personnel, information, facilities, programs and activities, and technical capabilities."

Brown's website offers its own online "A Reader's Guide to Washington, D.C.: In the Steps of *The Lost Symbol*" which emphasizes the fact that "Architecture is itself a central character in Dan Brown's *The Lost Symbol*."

Links:

DAN BROWN "A READER'S GUIDE TO WASHINGTON, D.C."
www.danbrown.com/html/novels/theLostSymbol/tour_dc.html

LIBRARY OF CONGRESS VIRTUAL TOUR
myloc.gov/exhibitspaces/Pages/default.aspx

CENTRAL INTELLIGENCE AGENCY
www.cia.gov

THE LOST SYMBOL SET OF D.C. PHOTOS ON FLICKR
www.flickr.com/photos/bom_mot/sets/72157622269892249

The L'Enfant Design

How is it that this capital city of the new United States is so rich in Masonic history and symbols? How could a New World American city be planned with castles and crypts, obelisks and temples? Americans are taught that the city of Washington was constructed out of nothing, not unlike the Russian St. Petersburg of Peter the Great. In January of 1791, George Washington chose the land in Maryland that is now the District of Columbia, and a smaller section across the Potomac in Virginia. In the same year Virginia and Maryland (some see a hidden *Virgin Mary Land*) officially ceded the territory for the city. In September 1791, the new city commissioners met with the Secretary of State (and later President) Thomas Jefferson to choose the name for the city. It came as no surprise that the new city would bear the name of the man who had been "first in war, first in peace, and first in the hearts of his countrymen." Pierre Charles L'Enfant who was responsible for the concept and design of the city first suggested "Washingtonople," explicitly recalling the glory of the great Constantinople, but that choice was rejected. The commissioners also named the ten-mile square of the Federal District "Columbia," a Latin-sounding term derived from

Christopher Columbus, representing the Goddess of Democracy.

Washington engaged Major Andrew Ellicott to survey the District in February and commissioned L'Enfant to design the new city. Washington frequently met and dined with others, as did his commissioners, at Suter's Fountain Inn at the intersection of 31st and K streets in Georgetown. John Suter, Jr., proprietor of historic Suter's Fountain Inn, was Senior Warden of Maryland Masonic Lodge No. 9, and the Inn was the meeting place of the Masonic lodge that President Washington, the Marquis de LaFayette, and Major L'Enfant all attended.

Ellicott, the original surveyor and himself a Mason, laid the symbolic cornerstone of city at Jones Point with commissioner Daniel Carroll with the traditional Masonic offerings of corn, wine, and oil on April 15, 1791. This Masonic ritual of the cornerstone laying would become a tradition and established custom for marking the dedication of important sites and constructions in the new nation.

The commissioners instructed L'Enfant to number and letter his streets in the way that we still recognize today. The city was originally intended to be a ten-mile-by-ten-mile square placed diamond-like on a map marking land between Maryland and Virginia, with the Potomac River flowing through the city. Unlike most cities, construction of Washington began with a comprehensive plan. The grid of streets running from north to south were numbered and today are identified by quadrant, such as 14th Street N.W. (for North West). Those streets running from east to west bore the names of the letters of the alphabet, such as K Street or M Street. These all are intersected on a diagonal by major avenues carrying the names of the first states. To appease those who hoped to locate the country's capital in Philadelphia, one of the city's major thoroughfares was

named Pennsylvania Avenue. All of this fascinates students of geography and geometry, especially when squares and circles are added to the mix. Triangles, squares, star-shaped pentagons, and hexagons can be overlaid onto the map resulting in an architect's and conspiracy buff's dream world. The emerging shapes continue to fascinate students of conspiracy and the occult. The most famous of these is the upside-down pentagram reported to be Lucifer's own imprint on the city. But Langdon (and Brown) wisely dismiss these allegations of any diabolical design or overlay on the map.

Even the casual observer, however, can identify the geometrical perfection created by the main points of the city that begin at the White House and look south toward the Washington Monument. From the monument, looking east across the Mall, one sees the majestic outline of the U.S. Capitol, and every four years the Inaugural Parade completes the triangle when the new President proceeds

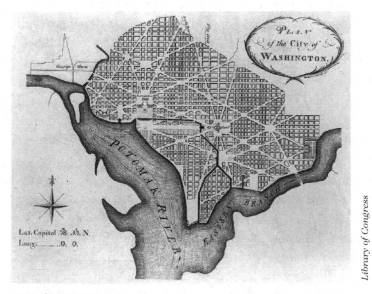

L'Enfant's Design

northwest along Pennsylvania Avenue from the Capitol back to the White House. What a shame that in 1836 the Treasury Building designed by a Mason, Robert Mills, who was also the architect of the Washington Monument, now blocks what once was an unobstructed view between those two seats of power.

L'Enfant's original master plan called for three main focal points: the President's House (today the White House), the Congress House (the Capitol), and a place for a monument to George Washington (site of the Washington Monument). L'Enfant was a master designer, but not a very clever politician and/or businessman. He quarreled with landowners, and his lack of consideration for financial matters would eventually lead to his downfall. He had visions of streets 100 to 110 feet wide and avenues like Pennsylvania 160 feet wide! When Washington fired him in January 1792, he was offered $2,500 and a plot of land near the White House, which he refused. He died embittered and penniless in 1825. Only in the twentieth century were his remains given the honor of a military burial in Arlington Cemetery.

Links:

ORIGINAL PLAN FOR WASHINGTON, D.C.,
www.loc.gov/exhibits/treasures/tri001.html

STREETS ANDS HIGHWAYS OF WASHINGTON, D.C.
en.wikipedia.org/wiki/Streets_and_highways_of_Washington,_D.C.

THE LOST SYMBOL IN WASHINGTON, D.C
washington.org/visiting/experience-dc/the-lost-symbol

DAVID OVASON VIDEO
www.youtube.com/watch?v=sXlYHjQJZ4Y

LUCIFER IN D.C.
www.bibliotecapleyades.net/esp_tapestra11.htm

The New Rome

"*A*merica's intended destiny has been lost to history" (82). This sounds not unlike the title of the book by Manly P. Hall, *The Secret Destiny of America*. No more secret than the CIA Office of Security, the history has been overlooked or forgotten by most. Langdon gives us a mini-lecture on the city and its origins. He will call it the "*true* intentions of our nation's forefathers" (82). What is undeni-able is the striking number of buildings and monuments that capture the grandeur that once was Rome. Washington was built on seven hills as was Rome, along with Jerusalem, Moscow, and Istanbul (the former Constantinople). Langdon reminds us that the area occupied by Washington, D.C., once was even called Rome. Rome's Tiber River gave the name to the Tiber Creek that flows into the Potomac River near what is today Jefferson Pier, the original planned point for an equestrian statue of George Washington.

The city's geography perfectly supported the archi-tecture and art that embody the high esteem in which Roman culture was held by the new democracy. Rome had its constitution as did the fledgling United States in 1789, and a Senate with representatives of the people who made laws and balanced the power of the Emperor. American

political structures and the legal system were modeled in part on Ancient Roman traditions.

Washington became *de facto* a new Rome because of the multiple associations embedded in it by the founders. Thomas Jefferson suggested the Latin-sounding name Columbia to signify freedom for all. The Temple of Jupiter on the Capitoline Hill gave us the name for the Capitol. The city's wide avenues and prospects and its sweeping views mimic the Roman Forum. The architecture will be compared by Langdon to ancient pantheons, temples, and the gigantic obelisk. At the city's geographical center is the Capitol which houses over a hundred statues, and whose walls and ceilings are graced with frescoes and paintings on a scale reserved for cathedrals and the Vatican. The Capitol's classical columns and the Pantheon-like Rotunda that Langdon compares to the Temple of Vesta all evoke

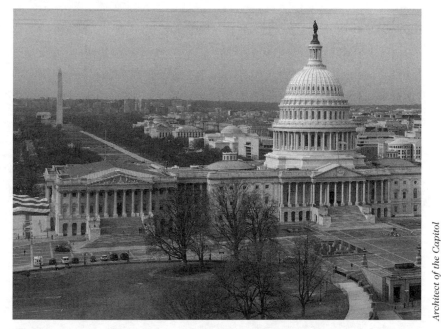

Architect of the Capitol

U.S. Capitol, with Washington Monument on left

Rome. There was also the Capitol Crypt, intended to hold the remains of George Washington, that mirrors the crypt in St. Peter's Basilica for Peter. The city of Washington was never intended to compete with Rome for grandeur, but it was intended to emulate it across the Atlantic. In an aside that reminds us of Rome and the main artistic figure of *Angels & Demons,* inside the Great Hall of the Library of Congress: "Langdon wonders what Bernini would have thought?" (182)

Links:

KEYS TO *ANGELS & DEMONS*
keysangelsdemons.wetpaint.com

WASHINGTON, D.C. THE LIBRARY OF CONGRESS VIDEO
www.youtube.com/watch?v=wKsX_0WWII0&feature=related

The Triangle

L'Enfant's master plan for the Federal Triangle survived and has endured up to the present day. He had proposed a great triangle that would connect the the White House with the Capitol and then back to a stunning statue for George Washington, replaced by the Washington Monument. The plan and that triangle in miniature are reproduced in stone on the ground at Federal Plaza, where Katherine and Robert exit their cab to enter the Metro. Located at 14th Street NW and Pennsylvania Avenue, the plaza cornerstone coincidentally contains a copy of the Bible.

Just as prominent Masons such as Washington and Ellicott had been involved with the foundation and planning of the city, so too did a Mason play a major role in the creation of the President's House, first officially called the White House by President Theodore Roosevelt in 1901. Captain James Hoban, an Irish immigrant architect, who won the competition and a $500 prize, came to Washington in June 1792 at President Washington's request to design and construct the Executive Mansion. Hoban was a Georgetown mason and later would become the Worshipful Master of Federal Lodge No. 15, inside of the District.

The cornerstone of the White House was laid October 13, 1792, in a Masonic ceremony by George Washington, Commissioner Daniel Carroll, the architect James Hoban, and Master Mason Collen Williamson, of Lodge No.9 of Georgetown. Their names appear on the brass plate laid under the stone. The White House is located at the northwest end of the triangle at 1600 Pennsylvania Avenue, so named because of the key role the city of Philadelphia had played in the American Revolution, the location of the signing of the Declaration of Independence. As one continues along the hypotenuse of the right triangle toward the east—the traditional Masonic move from west to east—one beholds the nation's Capitol, still the most imposing building in Washington, D.C.

On September 18, 1793, Masons gathered on Lafayette Square just north of the White House. Along with President George Washington they proceeded to the place where the Capitol now stands. Thomas Jefferson changed the name of Congress House, proposed by L'Enfant, to recall the Capitolium of Rome. The original design was by Dr. William Thornton, who would become the first Architect of the Capitol. But the final plan represented a compromise between Hoban and Stephen Hallet. So pleased was Washington by the cornerstone gathering at the President's House a year earlier, he led the march that was a highly publicized Masonic procession. At the site of the Capitol, Washington himself presided over the cornerstone installation. Inscribed on the silver plate placed on the original cornerstone were the names of two members of Federal Lodge, James M. Hoban, architect and superintendent, and Collen Williamson, master stone mason. That cornerstone also dated the laying of the stone in the year of Masonry 5793. (Masons date from 4000 years before Christ, A.L. "Anno Lucis," year of the light). The event is commemorated in

several artistic depictions of Washington laying the corner-stone. Langdon will refer to the one by Allyn Cox in the Cox Corridors of the Capitol on the House of Representatives side meant to complement the Brumidi corridors of the Senate. The gavel George Washington used was the handi-work of John Duffy, a silversmith and fellow Mason, and made of the same Maryland marble used in the interior of the Capitol building. President Washington presented the gavel to the Master of Lodge No. 9 of Maryland. The gavel would reappear at numerous ceremonies in United States history. It was at the cornerstone laying of the Washington Monument in 1848. At least ten presidents used or were present at the using of the gavel, including Theodore Roosevelt, Herbert Hoover, Harry Truman, and Dwight Eisenhower. Since 1922 the gavel has been stored in a spe-cially built box in a safe deposit vault of the Riggs National Bank in Washington, D.C. The silver trowel Washington used at the Capitol was crafted especially for the occasion by the same John Duffy of Alexandria. Washington present-

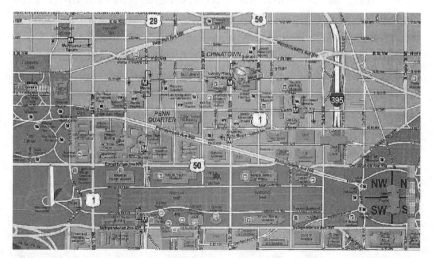

Triangle map of Washington, D.C.

47

ed the trowel to the Master of Alexandria Lodge No. 22. It has also been used by Alexandria-Washington Lodge No. 22 for numerous cornerstone ceremonies. Today, it is on public display in a special case in the George Washington Masonic Memorial in Alexandria, Virginia.

The largely unfinished construction of the Capitol Building was first occupied by the Congress and the Supreme Court in 1800. The Visitors Center that Langdon enters was opened only in 2008. He proceeds to Statuary Hall, where his attention is also drawn to the Rotunda and the Brumidi fresco on the ceiling. The Dome itself was redone during renovations that took place in the 1850s and the years following, somewhat impeded by the American Civil War, where the battlefields came close to the Capital located at the dividing line between the Northern and Southern States. The Rotunda is the large imposing circular room 96 feet in diameter and 180 feet in height. It connects the House and Senate sides, permitting passage between the two, and is visited by thousands of people each day.

The final point of the triangle, the memorial to President Washington envisioned by L'Enfant, was never built. The land on the intended spot could not support the planned structure and so the Washington Monument today is slightly offset from the original perfect triangle created with the White House and the Capitol. Even so, an aerial view (try Google Earth) reveals the triangular structure with the magnificent National Mall bounded on both sides by the Smithsonian Institute as well as the National Archives and National Gallery of Art, both of which also face out on Pennsylvania Avenue.

Links:

FREEDOM PLAZA
en.wikipedia.org/wiki/Freedom_Plaza

THE ARCHITECT OF THE CAPITOL
www.aoc.gov

MAP OF THE CAPITOL COMPLEX
www.visitthecapitol.gov/Visit/Capitol%20Complex%20Map

STATUARY HALL
clerk.house.gov/art_history/art_artifacts/virtual_tours/statu-ary_hall/index.html

FLOOR PLANS OF THE CAPITOL
xroads.virginia.edu/~CAP/FLOOR/cap_maps.html

Washington National Cathedral

"*A refuge containing ten stones from Mount Sinai, one from heaven itself, and one with the visage of Luke's dark father.*" (295). Robert and Katherine ride the Red Line of the Metro, as can you, to the Tenley-AU stop on route to the Washington National Cathedral. The official name is the Cathedral Church of Saint Peter and Saint Paul, located at Massachusetts and Wisconsin avenues. It was evident that the new nation under God would have a church. Pierre L'Enfant's original design for the city had intended a place at 8th and F streets, NW, for a "great church for national purposes." But it was never built and today the Smithsonian's National Portrait Gallery stands there. Over 100 years later Congress approved construction of a cathedral on Mount Saint Alban, one of the city's seven hills. An Englishman, Frederick Bodley, was selected as the head architect. President Theodore Roosevelt, a Mason, was present for the laying of the cornerstone on September 29, 1907. Even thought the Cathedral was still unfinished, it opened in 1912. It was completed only in 1990 when President George H. W. Bush on the same day, September 29, attended the placement of the symbolic last piece, the finial (the final tip of a gable or spire—the complement to the cornerstone).

This topping of the Cathedral also brings to mind the hermetic adage "As above, so below," to be uttered in the novel and that has found its way to the two scrolls on the back of the dustcover.

Langdon offers his own lecture tour to Katherine, noting that the ten stones commemorate the Ten Commandments given to Moses on Mount Sinai. The "rock from heaven" refers to a rock in one of the stain-glassed windows brought back from the moon by the Apollo 11 astronauts. There is a little known Masonic connection with the moon. The first two men on the moon, Buzz Aldrin and Neil Armstrong, apparently performed a "communion" ceremony "33" minutes after landing on the moon. Aldrin carried there and back a Masonic flag that he presented to the House of the Temple and it now hangs in the Library Museum. The "*visage of Luke's dark father*" refers not to the Luke of the Gospels, but to Luke Skywalker of *Star Wars*. The third place winner of competition for children to design decorative sculptures for the Cathedral was Christopher Rader, and his drawing of Darth Vader, sculpted by Jay Hall Carpenter, sits high upon the northwest tower of the Cathedral. It is just one of 112 gargoyles on the cathedral. A special gargoyle tour can even be arranged for the inquisitive.

The gargoyles are only a part of this neo-gothic structure that recalls the Cathedral of Notre Dame in Paris, and as the sixth largest cathedral in the world, the National Cathedral invites comparisons with the world's largest, St. Peter's Basilica in Rome. The top of the Gloria in Excelsis Tower is the highest point in Washington, and the Cathedral offers great views of the city from its observation tower. And there are 333 steps to the bell-ringing chamber in the great central tower.

This is a Cathedral of the Episcopal Church under the leadership of a Dean, the Very Rev. Samuel T. Lloyd III,

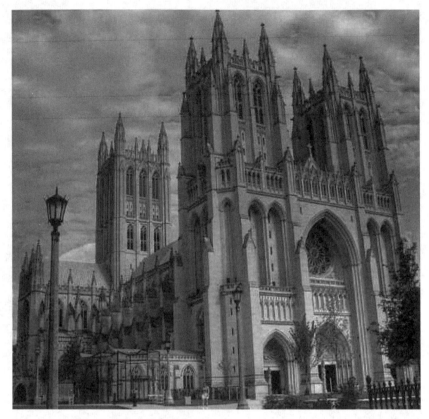

Washington National Cathedral

who was installed as the ninth dean of Washington National Cathedral on April 23, 2005. In the novel the dean is the Reverend Colin Galloway, a Freemason. He will point out to Langdon that the golden Masonic Pyramid given him by Peter Solomon is a map. The dean also makes an explicit connection between the scientific and the spiritual realms by quoting Einstein in support of the mystical, and admonishing Robert that "You do not yet have eyes to see" (309) echoing Mark 8:18: "Having eyes, do you not see."

The Cathedral has played a central role in American history and the power of Washington, and that history is

repeatedly intertwined with the participation of Masons. Four American presidents had funeral services here: Woodrow Wilson, once the President of Princeton University, is also buried here; Dwight Eisenhower; Ronald Reagan; and Gerald Ford, a Mason. A memorial service was held for President Harry Truman, also a Mason. In 1937 President Franklin D. Roosevelt, a Mason, instituted a prayer service the day after inauguration. Ronald Reagan in 1985, George H.W. Bush in 1989, George W. Bush in 2001 and 2005, and Barack Obama in 2009 have continued that tradition.

Links:

VIDEO OF THE NATIONAL CATHEDRAL
media.cathedral.org/DeanOnCBS.wmv

AN OVERVIEW OF THE CATHEDRAL
www.nps.gov/nr/travel/wash/dc5.htm

THE NATIONAL CATHEDRAL
www.nationalcathedral.org

A VIRTUAL TOUR OF THE NATIONAL CATHEDRAL
www.nationalcathedral.org/visit/onlineTours.shtml

SLIDE SHOW OF THE NATIONAL CATHEDRAL
www.youtube.com/watch?v=xkHJZVefxrM

House of the Temple
The Temple of the Supreme Council of the Thirty-Third and Last Degree of the Ancient and Accepted Scottish Rite

"*There is a hidden world behind the one we all see*"(465). The novel opens in the "colossal edifice at 1733 Sixteenth Street, NW...a replica of pre-Christian temple." The initiate is being lead through a Masonic ritual in the magnificent Temple Room. Brown's description of the architecture and furnishings is completely factual, from the sphinxes guarding the doors outside, to the perfectly square Temple Room with a thirty-three-foot-tall throne, and ancient alchemical, astronomical, Egyptian, and Hebraic symbols. The oculus in the ceiling looks down upon an altar of Belgian black marble, and upon that table the sacrifice of Mal'akh will, in a cruel parody of the sacrifice of Abraham, be re-enacted.

This building has remained strangely hidden from visitors to Washington, unless they were Freemasons. With the publication of the novel, it will surely attract newfound attention. But neither the building nor its insides have been kept deliberately secret. Quite the contrary. The Temple has

always welcomed visitors and for those unable to come to Washington there is a stunning virtual tour on the Internet. The website offers insight into and colorful photographs of this treasure house of America's Masonic heritage, from which most of the following information comes.

This Masonic Temple is the headquarters of the Ancient and Accepted Scottish Rite of Freemasonry, also called the Supreme Council, 33 Degree, Southern Jurisdiction. The temple was designed by a non-Mason, John Russell Pope. Pope was also the architect who designed the Jefferson Memorial, the National Archives, and the main building of National Gallery of Art. The Temple was inspired by the Mausoleum at Halicarnassus, one of the Seven Wonders of the Ancient World, called by Brown "the original *mausoleum*" (3). Freemason Elliott Woods, who helped design the House and Senate Office buildings, added Masonic touches to the Temple's design. He had been appointed "Superintendent of the Capitol Building and Grounds" in 1902 by President Theodore Roosevelt, a Mason. In 1921 Woods was honored as "Architect of the Capitol." The Temple cornerstone was laid on Oct. 18, 1911, and the building was completed in 1915.

The steps that lead to the bronze door rise in groups of three, five, seven, and nine. Two solid-block limestone sphinxes guard the entrance. The one on the right of the door (with its eyes half closed) is a symbol of Wisdom. The one on the left (with its eyes open and alert) is a symbol of Power. Over the tall, bronze doors, cut into the stone, is the statement, "Freemasonry Builds Its Temples in the Hearts of Men and Among Nations." The name "House of the Temple" is traditionally associated with the word *Heredom*, the clue that leads Langdon here to save Peter Solomon. This is an important word in Freemasonry. It comes likely from the Greek words *hieros-domos*, meaning "Holy House," that refers to

the Temple of Solomon, so central to Masonic ritual and symbolism. The word is also found in French Rose Croix rituals, where it refers to a mythical mountain in Scotland, the legendary site of the first such Rosicrucian Chapter.

The Temple has 33 columns surrounding the building, and each is 33 feet high. The building's address also contains the number 33. The highest degree in the Scottish Rite is the 33rd and the coat-of-arms of the Scottish Rite is prominently imprinted on the American edition dustcover of *The Lost Symbol*. The three-story building contains the first library open to the public in Washington. This library's collection holds the first Masonic book printed in America by Benjamin Franklin and the Bible used at George Washington's funeral.

The Temple Room furniture is made of Russian walnut, the floor is polished marble mosaic—tens of thousands hand-laid, tiny cubes. The windows serve as another symbol of the progressive search for more light. Crowning the center

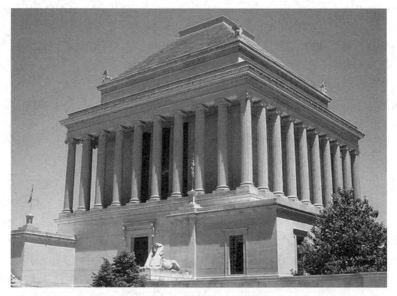

The House of Temple in Washington, D.C.

of the window is the Double Eagle, the symbol of the Rite. The Masonic search for the Light of Enlightenment is inscribed along the walls: "FROM THE OUTER DARKNESS OF IGNORANCE THROUGH THE SHADOWS OF OUR EARTH LIFE, WINDS THE BEAUTIFUL PATH OF INITIATION UNTO THE DIVINE LIGHT OF THE HOLY ALTAR."

The skylight is a vast polygonal dome, the oculus; it is intended to be a symbol of the vault of heaven. The dome soars nearly 100 feet (is it 33 yards?) above the altar, flooding the Temple Room with light. The light of the helicopter will shine through and its vibrations send the glass of the skylight crashing down on Zachary, outstretched upon the altar in the center of the room that bears the Hebrew inscription from Genesis 1:3: "AND GOD SAID, LET THERE BE LIGHT: AND THERE WAS LIGHT." The altar that holds a Bible and holy books of other religious traditions has inscribed around it: "FROM THE LIGHT OF THE DIVINE WORD THE LOGOS COMES THE WISDOM OF LIFE." This, of course, is the ultimate message of the novel: the Lost Symbol is the Lost Word, the Divine Logos, inscribed in the Bible and other sacred writings.

Links:

THE SUPREME COUNCIL ANCIENT AND ACCEPTED SCOTTISH RITE, SOUTHERN JURISDICTION, U.S.A
www.scottishrite.org

A VIRTUAL TOUR
www.scottishrite.org/visitors/vtour.html

THE FREEMASONS IN WASHINGTON
www.usnews.com/listings/freemasonry-in-washington/1-house-of-the-temple

SEARCH FOR DAN BROWN'S 'THE LOST SYMBOL': CLUE NO. 3
NBC TODAY SHOW
allday.msnbc.msn.com/archive/2009/09/10/2062910.aspx

The Washington Monument

The third point in the triangle envisioned by L'Enfant at the creation of the city was reserved for a monument to Washington. Such a memorial was first considered by the Continental Congress as early as 1783, and it was intended to be a statue of him on horseback. Only in 1833 was the Washington National Monument Society organized, and not until 1847 had substantial funds been raised from private contributions to begin construction. The winning design was submitted by Freemason Robert Mills for an obelisk rising 600 feet high from a circular colonnaded building 100 feet high and 250 feet in diameter. The immense size dictated a small relocation. Consequently, the monument is not in straight line with the White House as originally intended. The Jefferson Pier, some 390 feet west of the Monument, marks the original spot that would have completed the right triangle.

The Washington Monument was to be an American Pantheon, a home for statues of presidents and national heroes, with a colossal statue of George Washington. As construction progressed, the original design was modified significantly. The cornerstone was laid on July 4, 1848, again with elaborate Masonic ceremonies attended by President James

Polk, himself a Mason, utilizing the trowel and apron that George Washington had used at the laying of the cornerstone of the Capitol in 1793. A lack of funds and then the American Civil War brought construction to a standstill. Congress decided to complete the monument only in 1876, according to the new design of George Perkins Marsh, who had studied and sketched the obelisks of ancient Egypt and pointed out that the heights of the best-known obelisks were almost precisely ten times the base dimensions. Since the shaft of the redesigned monument was 55 feet square at the baseline, the Washington Monument was to rise to a height of about 550 feet (not the 600 feet of the Mills design). One of the outstanding engineering feats of the Washington Monument is the 55 foot pyramidion, which itself contains thirteen layers of marble, commemorating the original thirteen colonies. This is the pyramid shape that completes the classical obelisk. This unfinished pyramid is topped by another one, the capstone, which weighs 3,300 pounds (note the Masonic number 33). A third pyramid, the tip, comes to rest on the capstone which rests on the pyramidion.

The capstone was finally set on December 6, 1884. The capstone tip is a 100 ounce (2.85 kg) aluminum tip, 5.6 inches on each side and 8.9 inches high, intended to be a lightning-rod. At the time it was the largest single piece of aluminum ever cast. Originally offered for $75, the tip actually cost $225. The tip is engraved on all four sides. "Laus Deo" (Praise be to God) is inscribed on the east face of the capstone tip. The other sides commemorate key dates and individuals. Langdon cannot possibly see the actual aluminum tip, but there is a replica made in 1984 by the original manufacturer that is now on display at the base of the monument.

Robert Langdon is blindfolded by Peter Solomon and taken to experience the Lost Symbol and the Lost Word.

59

Inside the monument there are 897 steps and fifty landings, but ascent to the viewing platform that provides views in all four directions is by elevator. This is all so mysterious and suspenseful, and naturally the monument is closed at night to visitors. But the wonders Robert Langdon beholds can be enjoyed by anyone! The Washington Monument is open daily, except on December 25, from 9:00AM to 10:00PM from April through August, and until 5:00PM from September to March. Admission is free, but tickets are necessary. Reservations can be made for a modest fee.

When it was completed in 1884 the Monument became the world's tallest structure by surpassing the Cathedral of Cologne, Germany. In 1889 it was surpassed by the 1,063 foot Eiffel Tower. The original cornerstone with a copy of the Bible has, to my knowledge, not been uncovered or opened to date.

Links:

THE WASHINGTON MONUMENT
www.nps.gov/nr/travel/wash/dc72.htm

GEORGE J. BINCZEWSKI "MAKING THE CAP"
www.tms.org/pubs/journals/jom/9511/binczewski-9511.html

THE ENGRAVINGS ON THE CAPSTONE
www.snopes.com/politics/religion/monument.asp

GARY T. SCOTT ARTICLE ON MASONIC ROLE IN THE MONUMENT
srjarchives.tripod.com/1997-06/Scott.htm

REPLICA OF CAP MADE FOR TIFFANY'S
farm4.static.flickr.com/3195/2296929886_942b89bbe8.jpg?v=0

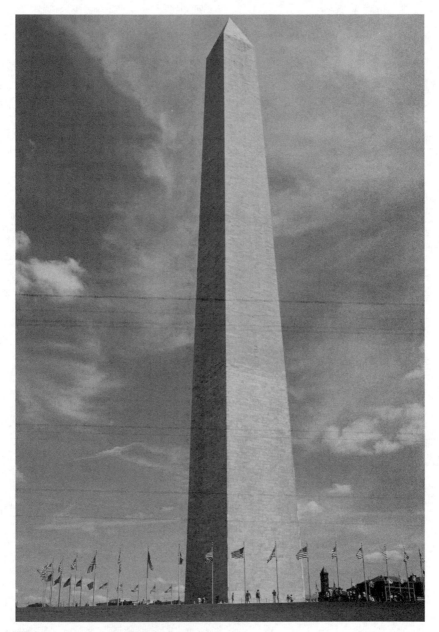

The Washington Monument

III.
ART AND ARCHITECTURE
>ⵏⵓⵍ ⵟⵠ >∨ < ⵢⵓⵟ ⵍ

A rt and architecture have been the mainstays of the Robert Langdon series. This to some extent is because Dan Brown's wife, Blythe (to whom all his books are dedicated), is an art historian whose work as a researcher and collaborator was noted during the London trial. In *Angels & Demons* the art of Gian Lorenzo Bernini (1598-1680) and the obelisks deposited throughout Rome, including one on St. Peter's Square, are keys to the pathway Langdon must follow in search of Hassassin. *The Da Vinci Code* opens in the Louvre Museum in Paris, and the *Vitruvian Man*, *The Mona Lisa,* and Michaelangelo's *The Last Supper* all provide important clues to the secret revealed at the end. In *The Lost Symbol* Brown once again highlights art and architecture. Brown's novels captivate readers in part through his use of familiar images that he forces us to reexamine, a technique called by the Russian Formalist critics "defamiliarization." This time it is the Dome of the Capitol and the magnificent fresco by Constantino Brumidi, *The Apotheosis of Washington*. Robert Langdon provides his own running commentary to the painting on the Dome's ceiling, but, as we shall see, it holds far greater mysteries.

Mal'akh has a secret entranceway to his basement prison hidden behind a painting of *The Three Graces*. The painting is mentioned so often that it too must hold some clue to the evil design of its owner. One of the first clues on the mission to find the Lost Symbol is a graphic image of 1514 AD that points Langdon to the artist, Albrecht Dürer, and his even more famous engraving *Melencolia I*. Katherine Solomon declares they have no time to examine the actual engraving and so she turns to the online catalogue of digital images at the Library of Congress. You too can find the secret square and examine in greater depth the symbolism of this enigmatic engraving.

As the art, so the architecture. The U.S. Capitol, as already noted, is replete with symbolism that connects it to Rome and even the Temple of Solomon. Finally there is the obelisk topped by a pyramid that Langdon flies over as he arrives in Washington. This 555-foot unidentified obelisk, *"America's Egyptian Pyramid"* (13), is one that most Americans will immediately recognize as the Washington Monument. Other works of art and architecture are mentioned, but there is barely time in the novel to marvel at them, such as John White Alexander's painting *The Evolution of the Book* and the Reading Room of the Library of Congress, "the most striking room in Washington. . . . *Maybe in the whole world.*" (183).

Links:

Through the Lens: the Wonders of the Jefferson Building
www.loc.gov/loc/lcib/0712/jeffbldg.html

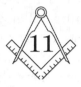

The Apotheosis of
George Washington

As he lectures the Director of the CIA Office of Security
on the hidden secrets of the U.S. Capitol, Langdon gives
a lesson in philology and art history. He defines "apotheo-
sis" as—'divine transformation'—that of man becoming
God" and then gestures to its representation in the fresco
on the ceiling of the Rotunda, *The Apotheosis of George
Washington* (84). Langdon continues with a verbal descrip-
tion and interpretation that can hardly do justice to this
1865 masterpiece by Constantino Brumidi. The finest single
source of information on the life and works of the artist with
spectacular graphics was done by Barbara Wolanin, Curator
of the Capitol, available at the link at the end of this chap-
ter. In what maybe the most fortuitous of coincidences,
William Henry and Mark Gray published in 2009 *Freedom's
Gate: The Lost Symbols in the U.S. Capitol,* the CD version
of which contains breathtaking-high-quality color photo-
graphs for closer examination.

Brumidi (1805-1880) was born and trained in Rome
and had painted in the Vatican and Roman palaces before
he came to the United States in 1852. He died in

Washington, D.C. Brumidi is credited with several works in the Capitol, but his masterpiece is undoubtedly *The Apotheosis*. In the central group of the fresco, George Washington is rising to the heavens in glory, flanked by female figures representing Liberty and Victory or Fame. They in turn are surrounded by thirteen maidens, who represent the original thirteen states. In the original drawings for the painting, there were thirty-three maidens. In the second sketch there were now thirteen maidens but thirty-three stars. The painting, according to Henry and Gray, is replete with Masonic and alchemical imagery.

A key to the painting is the word "apotheosis" (αποθεόω) which for the ancient Greeks means "to deify," to raise a person to the rank of a god, or the exaltation of a subject to the level of the divine. The concept of "Transformation" is key to the novel and to the Masonic legend that foresees the enlightenment of the individual and ultimately his acceptance of the death of the material body, but life for the spirit. The deification of Washington had begun in an earlier painting by John James Barralat, *The Apotheosis of George Washington,* in 1802. Here Washington is raised from the tomb, escorted by angels. The theme of Apotheosis had also been applied in *The Aptheosis [sic TRB] of the Spanish Monarchy,* dating to 1762-1770, by Giovanni Tiepolo. In 1841 an enormous twelve-ton sculpture of Washington sitting on a throne like Jupiter had been placed in the Rotunda. The sculpture was the creation of Horatio Greenough (who attended Phillips Academy which competes with Phillips Exeter, and later studied at Harvard and in Rome). Brown mentions the statue that had displeased some because of the depiction of the bare-chested Washington, and it was moved two years later to another section of the Capitol. Eventually it made its way to the Smithsonian Museum of American History,

where it can still be viewed today. Like Director Sato, you can "Google" the phrase "George Washington Zeus," if you wish a sneak peek and history lesson.

The very concept that man can become a god is a central tenet of Deist thought. Deists believe in a Supreme Being, but assume that He is no longer involved with His creation. The new American Republic and its first leader are shown a pathway to the heavens rising from the center of the nation's Capitol and of its capital city through the Dome above the Rotunda. Washington and we are to arise again and ascend in imitation of the resurrection and ascension of Jesus Christ. Ironically, George Washington, who in his life shunned attempts to be made king and turned down a third term in the office of the presidency, would likely have been embarrassed by such glorification and deification after his death.

The fresco itself is 180 feet from the floor and is 4,664 square feet. The figures are as large as 15 feet and can be easily seen from those standing on the Rotunda floor gazing up. Those who have visited the Sistine Chapel in Rome and admired the paintings on its ceiling will easily understand why Brumidi is known affectionately as the "Leonardo da Vinci of the Capitol." But the painting owes no less a debt to the work of Raphael, especially his *The Disputation of the Sacrament (Disputa)* in the Vatican Palace. (Readers might recall that Raphael's Tomb in Rome's Pantheon is the starting point for Langdon's adventures in *Angels & Demons*.) *The Apotheosis* itself, along with other works by Brumidi including the spectacular Brumidi Corridors on the Senate Side of the Capitol, give ample evidence of such influence.

Langdon describes the elements of the painting that he sees as key: gods and goddesses of antiquity participating in American history. The goddess Minerva appears with

Architect of the Capitol

The Apotheosis of Washington

Benjamin Franklin, Robert Fulton, inventor of the steamboat, and Samuel Morse, inventor of the telegraph and who studied religious philosophy at Yale. Neptune, god of the sea, helps lay the Transatlantic cable begun in 1857 for telegraph communication. Ceres, goddess of agriculture, sits atop the mechanical reaper invented by Cyrus McCormick in 1831 (the wheel of which is said to resemble a Templar Cross). Other scenes not mentioned in the novel include Mercury, god of commerce, Vulcan, outlined against a steam engine, and Freedom trampling tyrants.

Brumidi would also do much of the work on the Senate Reception Room, now used as the Vice President's Office, because the Vice President of the United States also serves as the President of the U.S. Senate. Brumidi would speak affectionately of his new homeland in America: "My

one ambition and my daily prayer is that I may live long enough to make beautiful the Capitol of the one country on earth in which there is liberty." He was just one of the immigrants who made up the fabric of the United States of America and reflects the motto that Langdon recalls in the painting at the end of the novel. The Latin phrase found in the banner held high opposite the figure of Washington reads: "E PLURIBUS UNUM" (*Out of many, one*) (504).

Links:

BARBARA WOLANIN, CONSTANTINO BRUMIDI ARTIST OF THE CAPITOL

www.gpo.gov/congress/senate/brumidi

OVERVIEW OF THE APOTHEOSIS
www.aoc.gov/cc/art/rotunda/apotheosis/Overview.cfm

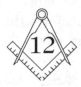

The Three Graces

When Katherine Solomon visits Dr. Christopher Abaddon in his office, she is treated to tea, a Solomon family tradition that hints at familial ties, the relationship of Abaddon to the Solomons. She stops to admire an original Michael Parkes oil painting, *The Three Graces,* noteworthy for the "nude bodies . . . spectacularly rendered in vivid colors" (93). The painting reappears again on several occasions and serves to conceal a secret doorway into the maniacal doctor's dungeon of torture.

The oil-on-canvas painting measures one meter by 1.3 meters, and was painted in 2004. Parkes is an American artist born in 1944 and described as a "magical realist painter." He has in fact commented on his own work:

> The Three Graces in Renaissance times were known as the hand maidens of the goddess, Venus. They were normally representing beauty, chastity, and pleasure because Venus was known as the goddess of love. This love is of an earthly or physical love. However, in earlier Platonic times, the Greeks had a more esoteric interpretation of that love that Venus embodied. They believed she was representing the highest form of spiritual love.

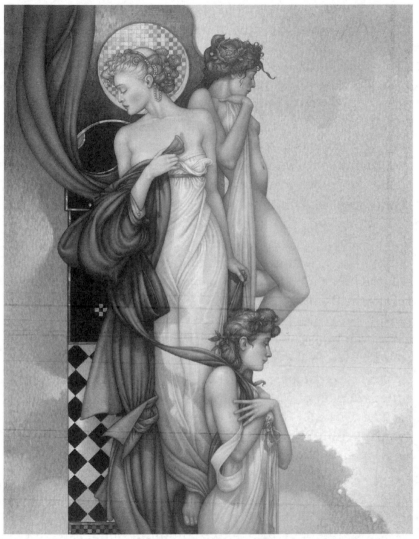

The Three Graces, painting by Michael Parkes (2004)

Therefore the Three Graces were not handmaidens to a Venus of earthly sensuality or love but they were stepping stones for the descent of the highest energies descending through the embodiment of Venus to the earth plane. They are Silence, Harmony, and Order.

The subject has been popular in Western art, including a very famous painting of the same name by Raphael. In one more curious coincidence, there is a gallery called "The Three Graces" in Portsmouth, New Hampshire, Brown's home state. But Kim Ferreira, herself an artist who opened the gallery in 2004, has no recollection of a visit by Dan Brown. Raphael was her, and perhaps Brown's, inspiration, and she has assembled an impressive collection documenting the art history of *The Three Graces* with reproductions, noted below. In part she highlights the aspect of "a trinity, physical and intellectual representations of charm, beauty and joy and a symbol of compassion and benevolence." There are three surviving members of the Solomon family, Peter, Katherine, and Zachary. Peter might be considered charming and Katherine beautiful, and Zachary thinks he is creative, but as Mal'akh or Abaddon, he is hardly benevolent.

The magic of words to describe these paintings fails to capture the eye's delight at the brilliant colors of Brumidi's *Apotheosis* or Parkes' *The Three Graces*. An illustrated version of *The Lost Symbol* is surely on the way. As for *The Three Graces* itself, I suspect it will not only call to mind pleasant associations, but also reveal secrets to the text on closer examination.

Links:

THE THREE GRACES
www.theworldofmichaelparkes.com/html/Detail.asp?WorkInvNum=9336&whatpage=artistfull

THE WORLD OF MICHAEL PARKES
www.theworldofmichaelparkes.com/html/home.asp

THE THREE GRACES A HISTORY BY KIM FERREIRA
www.threegracesgallery.com/graces.html

VIDEO OF MICHAEL PARKES ON HIS VENUS PAINTING
www.youtube.com/watch?v=XEc-8J7O0o4

Melencolia I

Even before the book's publication Brown had pointed at Dürer in two of the clues offered simultaneously to readers on Facebook and Twitter. Clue #22 was "His subjects are the first couple, horned ungulate, blessed Jerome." Many eager puzzle-solvers realized this was a veiled reference to Dürer. The first couple was Adam and Eve, engraved and painted by the artist; he also did an engraving of a Rhinoceros, and one of St. Jerome who translated the Bible into Latin. On the box of the golden pyramid, Langdon discovers the image of 1514, above a capital letter "A" that sits above and encloses the letter "D." Langdon recognizes this as an unmistakable reference to a name. But he keeps the secret for several chapters until revealing it to be the signature of Albrecht Dürer that graces the artist's engraving *Melencolia I*. With no time to waste, Katherine suggests they access it in the online catalogue of digital collections at the Library of Congress. The search reveals a number of thumbnail images, including one for *Melencolia I*. A recent search of the Library of Congress catalogue reveals no such print in their collection. Fortunately the National Gallery of Art has several copies and provides Internet access to a print where

each section can be viewed in detail. The engraving embodies a magic square that will be discussed in some detail later, as well as the signature block in the lower right-hand corner that had attracted Langdon's attention. But the entire engraving fits into what is called "Mystic Christianity—a fusion of early Christianity, alchemy, astrology and science" (257).

In 1514 Albrecht Dürer created this engraving that contains its title and the year of its creation. It is one of the most studied works of art in the Western world. Erwin Panofsky, considered by many the foremost authority on the work, claims in his *The Life and Art of Albrecht Dürer* (1943) that it "is in a sense a spiritual self-portrait of Albrecht Dürer." Dürer had visited Florence and was acquainted with the art of Raphael and Leonardo da Vinci. The title, *Melencolia I,* is likely related to the phrase used by one of the major esoteric writers of the Middle Ages, Heinrich Cornelius Agrippa, whose *Of Occult Philosophy* was written in 1510 and published in 1531. In spite of countless attempts at interpretation, the work continues to exhibit new possibilities. In addition to having been used in *Of Occult Philosophy* and a misspelling in any of the languages Dürer knew, *Melencolia* could be read as an anagram for the Latin *Limen coela,* or "threshold to heaven."

Scholars have interpreted the images and symbols to contain some secret wisdom. The title itself has been interpreted as an example of *gematria,* assigning numbers to letters to reveal hidden correspondences. If one assigns the numeral 1 to the letter A, 2 to B etc., then
MELENCOLIA EINS =
(13+5+12+5+14+3+15+12+9+1)+(5+9+14+19) = 136
and ALBRECHT DVRER =
(1+12+2+18+5+3+8+20)+(4+22+18+5+18) = 136.

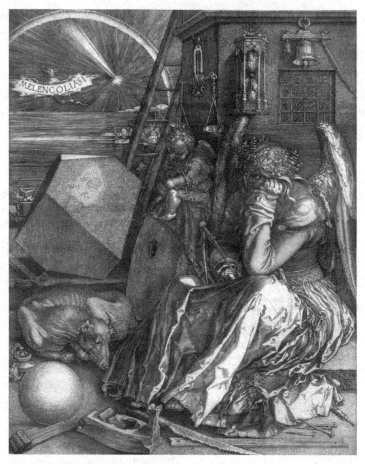

Melencolia I, engraving by Albrecht Dürer (1514)

(Note the Latin letter *V* replaces the letter *U* in the artist's name.)

The intriguing magic square in the engraving is a four-by-four set of the numbers from 1 to 16, where each row and column adds up to 34, related in some Hermetic texts to the planet Jupiter. The bottom row contains the numbers 4-15-14-1, which some argue is the date (1514) and a code for the letters A=1 and D=4 for Albrecht Dürer.

Mark Koltko-Rivera connects the paintings to the Masonic tradition, although Freemasonry Lodges trace their formal beginnings to the year 1717, two centuries after the work itself. He focuses our attention on the objects such as the tools of a carpenter (Jesus was the son of a carpenter), the compasses, the polished stone, and even the dog. The ladder is perceived as Jacob's ladder (see Genesis 28:10-22), a symbol from the lecture of the first degree of Freemasonry.

Links:

MELENCOLIA I AT THE NATIONAL GALLERY OF ART IN WASHINGTON, D.C.
www.nga.gov/fcgi-bin/timage_f?object=6640&image=3653&c=

ALBRECHT DÜRER, THE COMPLETE WORKS
www.albrecht-durer.org

DAVID BOWMAN "MELENCOLIA I."
www.aiwaz.net/Melencolia-I/a14

DAVID FINKELSTEIN "MELENCOLIA I."
www.physics.gatech.edu/people/faculty/finkelstein/MELEN COLIAchapter.pdf

MARK KOLTKO-RIVERA "MASONIC SYMBOLS IN DURER'S "MELENCOLIA I."
lostsymboltweets.blogspot.com/2009/06/9th-tweet-albrecht-durer.html

The Capitol

The U.S. Capitol dominates *The Lost Symbol* and is prominent on the dustcovers of the American and British editions of the book. Its role in the L'Enfant's Triangle and its Masonic origins have been noted. But the Capitol is also a living museum that has continued to grow with the Nation over the centuries. Architecturally and artistically, it is testimony to American creativity inspired by and imbued with a spirit of classical antiquity. It is fitting that the master of this place is designated the Architect of the Capitol. The Architect of the Capitol not coincidentally maintains a spectacular website on our nation's pride.

The site for the American legislative branch was selected by George Washington and Pierre L'Enfant. Designed by Dr. William Thornton, who helped Washington lay the cornerstone on September 18, 1793, the building was not occupied until 1807, years after Washington's death. During America's War with the British, the building was burnt down in 1814. While it was soon restored, the building underwent expansion in the 1850s and 1860s, even in the course of the American Civil War. A new U.S. Capitol Visitors Center was opened in 2008. Americans frequently

speak of "Capitol Hill" as the place where congressmen work, debate, and pass the laws that govern our nation.

The center of the American legislative branch, the Capitol is indeed a temple, the seat of a government of an independent people protected by a constitution. Here convene the Senate, not unlike the Roman Senate, and the House of Representatives. The building itself has a long and colorful history, and according to various sources, the Capitol can be compared to the Roman Pantheon, the Temple of Jupiter, Solomon's Temple in Jerusalem, and it clearly has been inspired in part by St. Isaac's Cathedral in St. Petersburg, Russia.

Langdon and Mal'akh, as do most visitors, enter the Capitol via the new Visitors Center. Since it has just recently been opened even most Americans who have visited before would be surprised to discover their Capitol anew. The Capitol is a working place where the House and Senate conduct in public sessions to debate and adopt legislation. But it is also a museum that celebrates the American democracy. Visitors, as well as Langdon, are directed to the Rotunda, the floor below the magnificent Dome, where Langdon views *The Apotheosis of George Washington* and unfortunately finds the tattooed "hand of mystery" of Peter Solomon. Langdon will also descend into the subbasement of the Capitol, to the secret Room 13, where he first discovers the Chamber of Reflection and an unfinished pyramid. The Chamber of Reflection in the Capitol basement is a fiction. Brown admitted as much in a television interview.

From there, he is guided by the Architect of the Capitol, a real title, but fictional officeholder Warren Bellamy (Walt Bellamy was a professional basketball in the NBA in the 1960s and 1970s). He will help Robert evade Director of the CIA's Office of Security Sato (a common Japanese surname and one that can mean "sugar"). They

use one of the underground tunnels that connect the Capitol to the three buildings of the Library of Congress across the street. There is, in fact, a subbasement to the Capitol and the tunnel actually exists. Originally the Library of Congress had been established specifically to support the needs of representatives to Congress and their staffs, and for a time it was located in the Capitol Building. There are actually underground rail lines and tunnels that connect the Capitol to the six buildings that hold the offices of senators and representatives. The Capitol Dome, where Langdon and Katherine will end their journey and the novel, is topped by a Statue of Freedom. Access to the top of the Dome that Langdon ascends can be arranged by special permission.

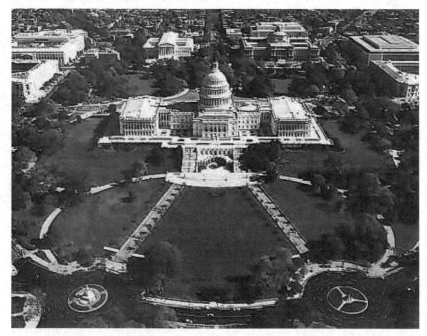

Architect of the Capitol

Aerial view of the Capitol

Books have been written and websites abound about the placement of the Capitol and the zodiacal significance of the exact time for the laying of the cornerstone. One of the most recent and complete overviews can be found in David Ovason's *The Secret Architecture of Our Nation's Capital* (1999). The cornerstone itself was symbolically re-laid in 1993 with Masonic hours. Readers will wonder at this "treasure trove of bizarre arcana" from the "killer bathtub," "General John Alexander Logan's long-deceased stuffed horse" (25). All of this and much more appear in a book by Jim Berard, *The Capitol Inside & Out* (2003). But these anecdotal and mystical explanations of the Capitol are but a supplement to the rich and varied history of America's Temple of Power, which is available on the Internet, including spectacular photographs and detailed maps of the Capitol Complex and the Capitol Building itself.

Perhaps most impressive are the building's dimensions.

Today, the Capitol covers a ground area of 175,170 square feet, or about 4 acres, and has a floor area of approximately 16½ acres. Its length, from north to south, is 751 feet 4 inches; its greatest width, including approaches, is 350 feet. Its height above the base line on the east front to the top of the Statue of Freedom is 288 feet; from the basement floor to the top of the dome is an ascent of 365 steps. The building contains approximately 540 rooms and has 658 windows (108 in the dome alone) and approximately 850 doorways.

Under the Dome on the second floor is the Rotunda, 96 feet in diameter and which rises 180 feet 3 inches to the canopy. To the south of the Rotunda is the National Statuary Hall, where Langdon assumed he would give his speech. It is 365 steps from the Capitol basement to the top of the outer

dome, a steep climb up a narrow metal staircase that snakes between the double dome, out of sight to visitors below, to an outdoor walkway. One final Masonic coincidence is that there are thirty-three steps that lead from the Inauguration site on the west side of the Capitol up to the Rotunda!

Links:

A TOUR OF THE CAPITOL
uschscapitolhistory.uschs.org/tour/index.htm

C-SPAN VIDEO AND AUDIO GUIDE
www.c-span.org/capitolhistory

THE ARCHITECT OF THE CAPITOL
www.aoc.gov and
www.aoc.gov/cc/capitol/index.cfm

U.S. CAPITOL VISITOR CENTER
www.visitthecapitol.gov

The Obelisk and the Pyramid

Dan Brown is fascinated by obelisks and pyramids, and his coverage in *The Lost Symbol* is no exception. One need only recall the major obelisks in Rome and Bernini's creations that lead the way and stand before the deadly cathedrals of *Angels & Demons* or the glass pyramid above the Louvre at the end of *The Da Vinci Code*. The most obvious obelisk is the towering Washington Monument which at 555 feet is the tallest structure in Washington, D.C., and for a brief few years, it was the tallest structure in the world. The monument obelisk is topped off by a pyramid, on which another pyramid, the capstone, is placed.

The Washington Monument was originally envisioned as a large column. But construction was soon halted for almost three decades because of a lack of funds. When the building was redesigned what emerged was a classical design of an obelisk 555 feet high on a 55 foot base. These dimensions were intended to match the classical Egyptian proportion of 10:1. Viewed from directly above (or in Google Earth) the entire complex is a circumpunct, a point inside a circle, which somewhat closer reveals a perfect pyramid at the peak.

Obelisks and pyramids have from ancient times been accorded mystical qualities. The now predictable Professor Robert Langdon's mini-lecture informs us:

The pyramid essentially represents enlightenment. It's an architectural symbol emblematic of man's ability to break free from his earthly plane and ascend upward toward heaven, toward the golden sun, and ultimately, toward the supreme source of illumination (129).

A pyramid is a polygon with a base, topped by triangular sides converging at a point. There must be at least three sides, but the four-sided one is the one most seen. Pyramids date back four thousand years. The huge pyramids of Egypt have caused wonder among scientists and spectators, and given rise to all sorts of associations, from extraterrestrial involvement to the intercession of the gods, that might conceal the keys to mystical secrets. Since the pyramids did in fact contain secret passageways, the sense of the pyramid as a vessel of secrets is widespread.

The classical Egyptian obelisk has four sides tapering to a pyramid at its peak. Obelisks that directed one's eyes to the heavens also guarded the entrance to temples and were symbols for the Egyptian Sun god, Aman Re or Ra: *"The structure through which man elevated himself to the realm of the gods"* (130). Original obelisks were monoliths, a single piece of stone, but today they are more likely to consist of many stones. In modern times Rome is considered the obelisk capital of the world, with several original Egyptian ones and others added over the centuries, including the one in the middle of St Peter's Square.

The Freemasonic and other occult legends suggest that Egypt was inhabited by survivors of the lost island of Atlantis, that the Egyptian craft was passed along to those responsible for the construction of the Temple of Solomon,

The Masonic Structure

Scottish Rite

33° Sovereign Grand Inspector General
32° Sublime Prince of the Royal Secret
31° General Inspector Inquisitor Commander
30° Grand Elect Knight K–H
29° Knight of St. Andrew
28° Knight of the Sun
27° Commander of the Temple
26° Prince of Mercy
25° Knight of the Brazen Serpent
24° Prince of the Tabernacle
23° Child of the Tabernacle
22° Prince of Libanus
21° Patriarch Noachite
20° Master Ad Vitam
19° Grand Pontiff
18° Knight of the Rose Croix of HRDM
17° Knight of the East and West
16° Prince of Jerusalem
15° Knight of the East or Sword
14° Grand Elect Mason
13° Master of the Ninth Arch
12° Grand Master Architect
11° Sublime Master Ejected
10° Elect of Fifteen
9° Master Elect of Fifteen
8° Intendent of the Building
7° Provost and Judge
6° Intimate Secretary
5° Perfect Master
4° Secret Master
3° Master Mason
2° Fellow Craft
1° Entered Apprentice

York Rite

Order of Knights Templar
Order of Knights Malta
Order of Red Cross
Royal Arch Mason
Most Excellent Master
Past Master (Virtual)
Mark Master
Master Mason
Fellow Craft
Entered Apprentice

Prison Warder Consciousness

Global Elite

Masonic pyramid

and that societies such as the Knights Templar, the Rosicrucians, and the Freemasons are the recipients and guardians of those secrets. America, some propose, is an incarnation of the ideal society described by Sir Francis Bacon in *The New Atlantis*. The New World nation is supposed to have inherited this wisdom. This fact, the truth that America holds some ancient secret, is purported to be revealed in the symbolism of the unfinished pyramid that adorns the back side of the Great Seal of the United States and is carried by hundreds of millions of people each day, on the reverse side of the U.S. one dollar bill.

But is there another pyramid that is the closely guarded secret of the Masons, one that is supposed to reveal the *secret portal* to all wisdom? The Masonic Pyramid (131). The legend of the Masonic Pyramid, as recounted by Langdon, speaks of "a *hidden* pyramid–designed to protect the Ancient Mysteries until the time that all of mankind was ready to handle the awesome power that this wisdom could communicate." (131). But his disclaimer is that it is "all myth." In the Capitol subbasement he finds a nine-inch, solid, unfinished granite pyramid. It will hold one set of clues. Another mini-pyramid is the one made of gold that had been entrusted to him by Peter Solomon. Langdon returns it to Washington and then deciphers it only to find that it too bears symbols. These symbols, he discovers, are themselves marks on a treasure map that is to lead to the Lost Symbol and the Lost Word. But while there is a clear connection between pyramids and Freemasons, even as to the pyramid shape of the Temple Room itself in the House of the Temple, this "Masonic Pyramid" is one of the great fictions of the novel.

Links:

THE GREAT SEAL OF THE UNITED STATES
www.usa.gov/About/Great_Seal.shtml

PYRAMIDS: THE INSIDE STORY
www.nationalgeographic.com/pyramids/pyramids.html

SECRETS OF THE PYRAMIDS
www.secretsofthepyramids.com

OCCULT PYRAMID SYMBOLS
www.youtube.com/watch?v=SjJl9AX4FVE

IV:
CRYPTOLOGY

>ПОᄂ ᄃᄼ >ᄼ <ᄃᄂᄃ ᄂ

From the Capitol Crypt, intended for the remains of George Washington, to Cryptology, Dan Brown delights readers with codes and ciphers that he must surely enjoy himself. A basic device of each and every novel is not only the clues hidden within, but those contained on the cover art and the games or quests that his readers must decipher along with the grand decoder, Robert Langdon. In this regard Brown is not unlike the verbal conjuror Vladimir Nabokov, who in his novel *Lolita* complains of those authors who put their clues in italics, only to place a clue to the mysterious child abductor in italics himself. And few authors like *italics* as much as Brown does.

On his web page, newly updated in 2009 just before the publication of *The Lost Symbol,* Brown gathers his past and present challenges, including how to get inside the site itself. Try passing your cursor over the portion of the painting of *The Apotheosis* to reveal a portrait of our favorite author. Clicking on "The Secrets" on the left-hand side will provide access to several games, including "The Symbol Quests" as well as *The Da Vinci Code* web contest and "Uncover the Code," an *Angels & Demons* game. There are

sites of bizarre facts for the Langdon series novels, and some fun with ambigrams, the art of calligraphy to represent a word right side up and upside down identically, which served as the basis for *Angels & Demons*. There is even an Apple Iphone/Itouch application for "The Symbol Quest."

The novel is one long series of puzzles and codes that when deciphered lead one after another toward the final solution, the place where "all will be revealed." The novel actually begins its "Fact" list with mention of a letter given to the director of the CIA. Later in the Capitol Rotunda an unsuspecting tourist makes a macabre discovery of a "Hand of Mystery," indicating some sinister, occult knowledge that Langdon must interpret if he is to save the "soul" of his friend, Peter Solomon. The first of these is the Freemason Cipher needed to decode the message. The inside of the hand reveals the clue 1514 AD, which directs Langdon to the Albrecht Dürer engraving, in particular to its magic square. The gibberish provided by the Freemason Cipher becomes meaningful only when passed through the decoder by using Dürer's square.

The gold pyramid that Langdon is protecting under-goes its own transformation to reveal a far more complicat-ed set of symbols. That transformation can only be accom-plished when the anagram concealed in the solution to the deciphered Dürer message points to Isaac Newton. The symbols then lead to another mystery of the Order 8 Franklin Square, first misinterpreted as a geographical loca-tion for several chapters. Those who successfully arrive at the end of the novel and its unveiled set of symbols can turn their attention to a completely new set of challenges on the book's dustcover. The front, back, and spine contain refer-ences to *The Lost Symbol*, offer a prize for the lucky few who deciphered it early, and may provide the first clues to Robert Langdon's next adventure. In his *NBC Dateline*

interview, Brown hinted that his next novel will be filled with a bigger and set of challenges:

Dan Brown: The most fascinating code I left out of this book.

Matt Lauer: Why?

Dan Brown: Be– it was too complicated. It was just too tough to use. . . . Well, I'm not gonna tell you about it. It's in the next book.

Links:
DAN BROWN SECRETS
www.danbrown.com/#/secrets

Kryptos

One of the first hidden messages on the dustcover of *The Da Vinci Code* was a set of geographical coordinates. On the backside is a set of letters and numbers written backwards to the left of the fourth comment. They are latitude and longitude coordinates that when reversed read (37 57 6.5 N, 77 8 44 W). The coordinates (38 57 6.5 N, 77 8 44 W) point to the headquarters of the Central Intelligence Agency. The coordinates on the book cover are one degree off (37 instead of 38), and the reason for which Brown had said that he might reveal in future books. Moreover inside the darkened area where there is a tear in the cover, there is a text that reads in its mirror image: "only w.w. knows." Brown has stated that this refers to William Webster, who was the Director of the Central Intelligence Agency from 1987 to 1991. Webster is a graduate of Amherst, coincidentally the same college Brown attended. On *The Lost Symbol* "Fact" page, Brown mentions a 1991 document given to the director with cryptic text that "includes references to an ancient portal" and the phrase *"It's buried out there somewhere."* (1). Uninitiated readers will wait until almost the end of the novel to read on a CIA Employee Discussion Board the word "KRYPTOS" (475). The explanation why

Brown was one degree off, pointing not to the CIA but to Washington, D.C., is provided in a comment:

> Even though Mark said the code's [*The Da Vinci Code*, TRB] lat/long headings point <u>somewhere in WASH-INGTON, D.C., the coordinates</u> he used were off by one degree—Kryptos basically points back to itself.

Those who have followed the novels closely, will recognize that Brown had actually indicated Washignton, D.C., as the setting for *The Lost Symbol* on the cover of *The Da Vinci Code.* All these points lead to the open mystery of the sculpture designed by James Sanborn for the CIA entitled *Kryptos. Kryptos* has a long history and dozens of websites devoted to it, the best perhaps being the one by the CIA itself. In 1988 American-born artist James Sanborn was commissioned do a work of art for the new CIA headquarters. He collaborated with a writer to select the text and a retired CIA cryptographer to encode a message. This message was engraved on an S-shaped copper screen. Sanborn himself has said: "They will be able to read what I wrote, but what I wrote is a mystery itself." The artist did, however, provide the solution to the code and presented it to then Director Webster when the building was occupied in 1991. The actual code has been partially deciphered, but a section still remains unsolved. In the novel, a CIA employee, Nola Kaye, re-examines portions of the message and the online discussion board. "Nola Kaye" has been deciphered on a number of sites as an anagram transliterated from the Cyrillic for YA ELONKA (Я ЕλOHKA) that translates from Russian to "I am Elonka." This is Brown's homage to Elonka Dunin, who for years has covered Kryptos on her dedicated website.

The first of the deciphered parts refers to darkness and the ancient quest for enlightenment. The second iden-

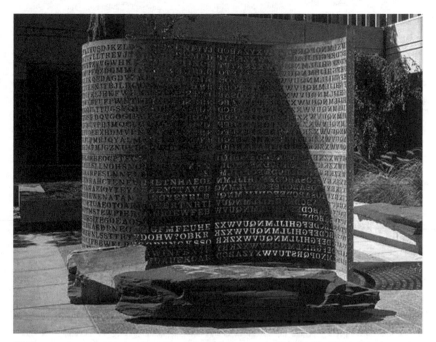

Kryptos sculpture, by Jim Sanborn, at the CIA Headquarters

tifies "who knows. Only ww." There are also the latitude/
longitude coordinates just two hundred meters from the
sculpture. The final passage is correctly identified in the
novel as coming from the writings of Howard Carter, the
archeologist who found the Tomb of Tutankhamen in the
Egyptian Valley of the Kings. Carter's own words supply the
phrase "ANCIENT PORTAL" (476).

BETWEEN SUBTLE SHADING AND THE ABSENCE OF LIGHT LIES
THE NUANCE OF IQLUSION
IT WAS TOTALLY INVISIBLE HOWS THAT POSSIBLE ? THEY USED
THE EARTHS MAGNETIC FIELD X THE INFORMATION WAS GATH-
ERED AND TRANSMITTED UNDERGRUUND TO AN UNKNOWN
LOCATION X DOES LANGLEY KNOW ABOUT THIS ? THEY SHOULD
ITS BURIED OUT THERE SOMEWHERE X WHO KNOWS THE EXACT

93

LOCATION ? ONLY WW THIS WAS HIS LAST MESSAGE X THIRTY
EIGHT DEGREES FIFTY SEVEN MINUTES SIX POINT FIVE SECONDS
NORTH SEVENTY SEVEN DEGREES EIGHT MINUTES FORTY FOUR
SECONDS WEST X LAYER TWO
SLOWLY DESPARATLY SLOWLY THE REMAINS OF PASSAGE DEBRIS
THAT ENCUMBERED THE LOWER PART OF THE DOORWAY WAS
REMOVED WITH TREMBLING HANDS I MADE A TINY BREACH IN
THE UPPER LEFT HAND CORNER AND THEN WIDENING THE HOLE
A LITTLE I INSERTED THE CANDLE AND PEERED IN THE HOT AIR
ESCAPING FROM THE CHAMBER CAUSED THE FLAME TO FLICK-
ER BUT PRESENTLY DETAILS OF THE ROOM WITHIN EMERGED
FROM THE MIST X CAN YOU SEE ANYTHING Q (?)

[Misspellings in the original have been retained. TRB]

Only time will tell if the final message to this multi-layered puzzle is ever revealed. Sanborn meanwhile has continued working and two of his works introduce a Russian element. One is called *Antipodes* which is half in English and half in Russian. The other is the *Cyrillic Projector,* which contains a message entirely in Russian in Cyrillic script.

Links:

CIA KRYPTOS TOUR AND VIDEO
https://www.cia.gov/about-cia/virtual-tour/kryptos/index.html

ELONKA DUNIN'S KRYPTOS SITE
elonka.com/kryptos

NOVA SCIENCE NOW VIDEO
www.pbs.org/wgbh/nova/sciencenow/3411/03.html

WIKIPEDIA IS ONE OF THE BEST STARTING POINTS FOR KRYPTOS FANS
en.wikipedia.org/wiki/Kryptos

Right Hand of Mysteries

Mal'akh cuts off the right hand of Peter Solomon and smuggles it into the Capitol Building in a sling. This is a totally macabre travesty of the place of honor "at the right hand of the father." The severed hand serves several functions in moving the plot along. In a gruesome ironic twist to "Peter will point the way," the hand gestures to the ceiling above the Rotunda at the painting *The Apotheosis of George Washington*. The index and thumb extended upward are plagiarized, Langdon maintains, from Leonardo da Vinci's *The Last Supper, Adoration of the Magi,* and *Saint John the Baptist* (87). The hand also conceals within it the mysterious IIIX88S, that when turned upside down reads SBBXIII, indicating a room in the subbasement of the Capitol that Peter had occupied.

But the main interest of the hand is the fact that the fingers are tattooed with symbols. Langdon recognizes this as the "Hand of Mysteries" representing an invitation that had been used "through the millennia" (51). Langdon also notes the hand had usually been portrayed in "stone or wood or rendered as a drawing." What is he talking about?

The hand appears in a work by Bernard de Montfaucon, a Benedictine monk in the eighteenth century

who wrote about and illustrated Egyptian artifacts in his *L'antiquité expliquée et représentée en figures 1719–1724* (in English simply *Antiquities*). Langdon more likely is referring to the description and depiction provided in the twentieth century. This image and the modern-day explanation comes from what Brown calls the "core book," *The Secret Teachings of All Ages,* by Manly P. Hall.

Hall displays *The Hand of Mysteries* with an illustration by Augustus Knapp and provides the best single summation of the hand and its symbolism, in which each finger has it's own unique symbol. On the thumb, there is a crown; on the index finger, a star; on the middle finger, a sun; on the ring finger, a lantern; and on the pinky, a key. The citation in full by Hall reads:

> The hand of the philosopher which is extended to those who enter into the mysteries. When the disciple of the Great Art first beholds this hand, it is closed, and he must discover a method of opening it before the mysteries contained therein may be revealed. In alchemy the hand signifies the formula for the preparation of the tincture physicorum. The fish is mercury and the flame-bounded sea in which it swims is sulfur, while each of the fingers bears the emblem of a Divine Agent through the combined operations of which the great work is accomplished. The unknown artist says of the diagram: "The wise take their oath by this hand that they will not teach the Art without parables." To the Qabbalist the figure signifies the operation of the One Power [the crowned thumb] in the four worlds (the fingers with their emblems). Besides its alchemical and Qabbalistic meanings, the figure symbolizes the hand of a Master Mason with which he "raises" the martyred Builder of the Divine House. Philosophically, the key represents the

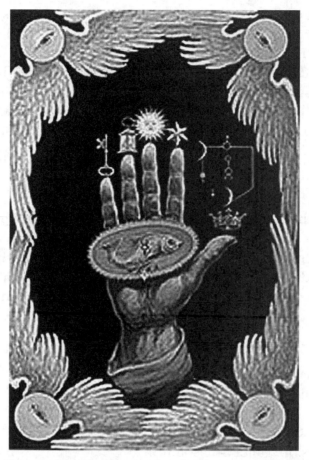

Mystic Hand, illustration by Augustus Knapp

Mysteries themselves, without whose aid man cannot unlock the numerous chambers of his own being. The lantern is human knowledge, for it is a spark of the Universal Fire captured in a man-made vessel; it is the light of those who dwell in the inferior universe and with the aid of which they seek to follow in the footsteps of Truth. The sun, which may be termed the "light of the world," represents the luminescence of creation through which man may learn the mystery of all creatures, which

97

express through form and number. The star is the Universal Light which reveals cosmic and celestial verities. The crown is Absolute Light—unknown and unrevealed—whose power shines through all the lesser lights that are but sparks of this Eternal Effulgence. Thus is set forth the right hand, or active principle, of Deity, whose works are all contained within the hollow of His hand.

Hall combines several traditions into one. The Qabbalist is the practitioner of the mystical Jewish Kabbalah, and alchemy and astronomy all figure prominently in the esoteric and occult symbols and stories of Freemasons. The astrological and astronomical worlds offer enlightenment, and all of this is contained in the Hand of the Lord. The Great Mysteries, their hidden wisdom, are all symbolized on one hand that invites us all to join in the search for ultimate wisdom.

Links:

KNAPP ILLUSTRATION AND EXPLANATION
icanseefar.tripod.com/hand_of_the_mysteries.htm

PBS GALLERY OF MASONIC SYMBOLISM
www.prs.org/gallery-mason.htm

Freemason Cipher

Langdon finds on the unfinished stone pyramid in SBB13 a four-by-four set of sixteen symbols (164). The symbols are illustrated twice more for a total of three times until he provides the Freemason Cipher that helps him decode it (197). The Freemason Cipher, sometimes called the Pigpen Cipher, locates the twenty-six letters of the English alphabet onto two three-by-three squares and two blocks of four. Each letter then corresponds to a single spot of the larger diagram. The cipher has been in use since the eighteenth century to keep the secrets of Masonry safe. But little is safe or secret on the Internet that offers several versions of the cipher. Be careful, some of these ciphers are off just a little to keep away the uninitiated! Langdon provides the key to decoding the message, but anyone can obtain it today on *Wikipedia* (197).

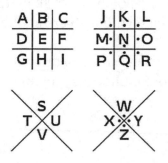

Using the corresponding table the message on the pyramid reads:

S O E U
A T U N
C S A S
V U N J

The result, however, is meaningless without further decoding that requires using the assistance of 1514 AD.

If you have not yet found and solved the Freemason Cipher in the lower left-hand corner on the back cover, now is the time to do so. For those without the American cover who wish to try their hand at deciphering I have constructed my own secret message. Can you solve it?

THE LOST
SYMBOL TRB
TRB

Links:

THE FREEMASON OR PIGPEN CIPHER
en.wikipedia.org/wiki/Pigpen_cipher

BACK OF THE LOST SYMBOL DUSTCOVER IMAGE
dailygrail.com/share/lostsymbolcovers/bookback.jpg

MAKE YOUR OWN ENCIPHERED MESSAGE
www.civilwarsignals.org/cipher/pigpencipher.html

THE LOST SYMBOL TRB

Dürer's and Franklin's
Magic Squares

Two of the most intriguing mysteries in the novel can be unraveled only when one employs magic squares to unscramble the letters or symbols. Magic squares appear in the ancient cultures of China, Egypt, India, and Persia. In a magic square the numbers in the rows across, the columns up and down, and the diagonals all add up to the same number. These squares were traditionally believed to have magical and mystical qualities, and often had astrological significance. Saturn corresponded to the number 3, Jupiter to 4, Mars to 5, the Sun to 6, Venus to 7, Mercury to 8, and the Moon to 9. The magic squares were just one use of combinations of letters and numbers found in occult or esoteric texts.

In the West some of the first magic squares appeared in the work of Heinrich Cornelius Agrippa's *Of Occult Philosophy,* written in 1510. The squares also appear in another esoteric text, *The Key of Solomon* or *The Clavicle of Solomon,* that dates back to at least the 1500s. The magic square from *The Key of Solomon* is the simplest three-by-three combination: the numbers 1 to 9 are arranged in three

rows and three columns and add up to 15, across, down, and diagonally.

Robert Langdon is at first mystified after having deciphered the Masonic Cipher consisting of four rows of four letters. Another clue points him to examine the enigmatic engraving by Albrecht Dürer who depicted a four-by-four magic square in his 1514 engraving *Melencolia I.* The engraving contains both its title and the year of its creation. *Melencolia* I appears in a scroll in the upper left hand of the engraving. The engraving or engravings (two copies exist) depict a female, Melancholy with wings, an angel, a rainbow, an hourglass, a ladder, a bell, and a polyhedron. All these constitute a seemingly chaotic or random array of alchemical, mathematical, and mystical objects. Even today the work continues to find new interpretations. *Melencolia,* as one scholar has pointed out, could also be an anagram and read as the Latin *Limen coela* or "threshold to heaven."

The most intriguing element of the work is the magic square, a four-by-four set of the numbers from 1 to 16, where each row and column adds up to 34, a number related in some Hermetic texts to the planet Jupiter. The bottom row contains the numbers 4-15-14-1, which some see not only as the date (1514) but also use a Masonic cipher to change the letters A=1 and D=4 for Albrecht Dürer.

Using the numbers contained on Dürer's square, Langdon unscrambles the letters.

S O E U	16 3 2 13	J E O V
A T U N	5 10 11 8	A S A N
C S A S	9 6 7 12	C T U S
V U N J	4 15 14 1	U N U S

This spells *Jeova Sanctus Unus,* which as any Latin student knows, translates as "One True God." (266). But Langdon is not finished, for we will find that this in turn is

an anagram for *Isaacus Neutonnus*, Sir Isaac Newton (322). Newton, Dan Brown fans will remember, made a brief appearance in *The Da Vinci Code* in connection with Sir Francis Bacon. Both were scientist philosophers and Bacon was the author of his own code, the Baconian Cipher. The name of Newton will itself provide a clue for deciphering the hidden symbols on the gold pyramid. Under a cover of wax are concealed symbols. But by utilizing the 33 degrees on the Newton Scale at which water boils, the symbols miraculously appear. They are for Langdon a revelation of sixty-four symbols that are also desperately in need of rearranging.

Links:

WOLFRAM MATH WORLD "MAGIC SQUARE"
mathworld.wolfram.com/MagicSquare.html

MELENCOLIA I AT THE NATIONAL GALLERY OF ART IN WASHINGTON, D.C.
www.nga.gov/fcgi-bin/timage_f?object=6640&image=3660&c=

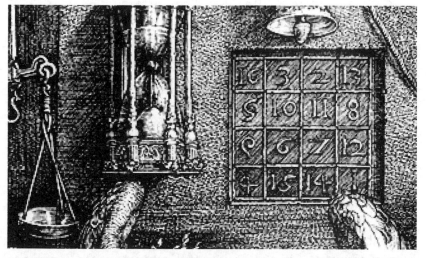

Detail from Dürer's Melencolia I

The Symbol Square

Under a cover of wax the golden Masonic Pyramid reveals its secret (377). But it is *Total chaos.* To bring "ordo ab chao" ("order out of chaos"), Langdon will have to resort to the Order Eight Franklin Square. Eight Franklin Square inspires several failed attempts because the phrase is misinterpreted as an address at 8 Franklin Square in Washington (and the Alamas Shrine Temple located just off Franklin Square). Langdon finally realizes that the phrase refers to the famous eight-by-eight magic square of Benjamin Franklin.

Benjamin Franklin (1706-1790) created his own set of magic squares, including one made up of sixteen rows and sixteen columns. Author, editor, scientist, statesman, diplomat, and one of America's founding fathers, he is most remembered for his contribution to the Declaration of Independence and his work to gain the aid of France in the cause of the American Revolution. Less well known is his status as a Mason and that he spent years in England where he likely interacted with members of the "Invisible College." He published the first Masonic book in America, and was also instrumental in the design of Washington, D.C., and the Capitol.

Franklin wrote about everything, and in *Poor Richard's Almanac* he gathered current wisdom and knowledge of the time. His collected sayings include "A stitch in time saves nine." He was fascinated by mathematical puzzles and constructed several magic squares and even a magic circle.

In the Order Eight Franklin Square that so mystifies Robert Langdon for several chapters, the numbers from one to sixty-four cover a field not unlike a chessboard, where the rows from left to right add up to 260, as do the numbers from top to bottom in each column. Unlike the true magic squares, the diagonals do not add up to the same 260, but Franklin created several original and intriguing diagonal designs that resemble pyramids.

52	61	4	13	20	29	36	45
14	3	62	51	46	35	30	19
53	60	5	12	21	28	37	44
11	6	59	54	43	38	27	22
55	58	7	10	23	26	39	42
9	8	57	56	41	40	25	24
50	63	2	15	18	31	34	47
16	1	64	49	48	33	32	17

Franklin's square

The sixty-four symbols make no sense by themselves. They are presented several times after they are first uncovered. (376). They only become clear when a transformation, similar to the one used with the Dürer square, is performed. By rearranging the symbols according the numbers in square, so that the letter in the last row second column is placed at the top right in the first column row one, etc., the symbols coalesce into a meaningful unit. Yes it will need unraveling and explanation too, but it leads to the novel's climax! (429).

The symbol chart or map (429) that emerges will need the expertise of Langdon to lead us through, row by row.

The first row contains the Greek word Ηερεδομ↓. The word, which we have seen associated with the House of the Temple, is followed by an arrow that will point south on a map of the city toward the Washington Monument.

The second row has *"The circumpunct. The symbol of the Source. The origin of all things."* It can also be read as the sun next to the moon in the sky or heavens.

The third row is originally misread as stonemasons' symbols; the square, the abbreviation for gold, the letter Sigma for the sum of all parts, a pyramid, the letter Delta for change, the sign for the alchemical element Mercury, and the Ourobous for wholeness and at-one ment (478). But in fact it will later reveal its secret as a stylized: *Laus Deo* "Praise be to God."

The fourth row has symbols for a star and moon, a cross and the Hebrew star, then three candles and a compass for Masonry.

The fifth row has the sun, the eye of Horus, the Moslem moon and star, the symbol of Yin Yang, an Ankh, and a box or coffin.

The sixth row contains within the pyramid or triangle the hand of peace, the Triquetra Celtic symbol of the Trinity, Om, a Buddhist wheel of life, the pentacle, and a Pythagorean triangle formed from three squares.

The seventh and eighth row contained signs of the Zodiac from left to right: Aries, Taurus, Gemini, Cancer, Leo, Virgo, Libra, Scorpio, Sagittarius, Capricorn, Aquarius, and Pisces.

Ultimately this will all lead us to the pyramid under which is buried The Lost Symbol, The Lost Word.

Links:

THE ALMAS SHRINE TEMPLE
www.graciano.com/project_detail.asp?pID=5

FRANKLIN'S MAGIC SQUARES
www.mathpages.com/HOME/kmath155.htm

Cover Clues

Few writers have cared so much about the composition of the dustcover art as has Dan Brown. The secrets concealed and unveiled on the cover of *The Da Vinci Code* have in part led us right to *The Lost Symbol*. It is only fitting that here too the cover art rewards those with time to survey it closely. A few experts are still at work furiously trying to decipher the clues, and one can only wonder if the editions in the United Kingdom have similar or different or any clues at all. And what about the foreign language editions? It is one reason to purchase the novel in hardcover, for the paperback editions of *The Da Vinci Code* conceal no such treasures.

Some of the art and associations are obvious. The front cover depicts on a raised imprint the of seal of the 33rd Degree Scottish Rite, with the number 33 inscribed in a triangle implanted upon the double headed eagle under a regal crown. The phrase *Ordo Ab Chao* is in the scroll below. Below the seal is a photograph of the U.S. Capitol illuminated at night. Inside the letter O of The Da Vinci Code is a dot, thus making a circumpunct. On the spine is a photograph of the Washington monument, hidden inside the keyhole.

Numerous people have rushed to examine the dust-cover, and many of its riddles and codes can be found and have been solved. But I want to give credit to my student at Middlebury College, Karly Wentz, who first unlocked the following secrets for me:

If you rotate the front cover 90 degrees to the right, along the drawn circle are numbers. Outside the circle reads: 22-65-22-97-27. Inside the circle reads: 22-23-44-1-133-97-65-44.

I went to all of those chapters and took the first letter of each word from every chapter. The result was: POPES PANTHEON. [Karly credits Greg Taylor's for the hint that Brown's novel *Digital Fortress* had a similar number and letter combination.]

I found all of the letters A through J on the cover with the corresponding number. Putting the letters in order I got, A2 B1 C2 D7 E8 F2 G9 H5 I1 J5. After a while I realized that this is a New York City phone number! 212-782-9515. I called, and learned if I'm one of the first 33 to figure out this clue, send an e-mail with my information, and correctly write Langdon's favorite symbol, I get a free signed copy of *The Lost Symbol*. [The number worked, but no longer connects to Jason Kaufman, Brown's editor. Callers in October 2009 were greeted by a foreign voice repeating a chant-like utterance. Someone may recognize this, but it is unclear how it might relate to the novel, TRB.] The back cover also holds in miniscule print AS ABOVE and below SO BELOW (in the upper and lower arches).

Also on the back cover, if you rotate the book 90 degrees clockwise, there is a red-orange code written across the top and bottom of the page. Using the Freemason Cipher, the code translates to reveal, "ALL

GREAT TRUTHS BEGIN AS BLASPHEMIES." This is a quote by George Bernard Shaw from his play *Annajanska, the Bolshevik Empress*. Shaw won the Nobel Prize in Literature in 1925. I couldn't find a summary of the play, but the entire one-act piece was written in 1918, and is online [at Project Gutenberg]. In my opinion, this could allude to Brown's next book having to do with the Bolshevik Revolution or Russian history.

The next code is a four-by-four grid on the bottom-left corner of the back cover, to the left of the last review. Using Albrecht Dürer's "magic square" where each number on the grid represents the number of the square where the letter in the matching grid should go. For example, if you look below, 'Y' should go to the 16th square, 'U' should go to the third square, 'O' should go to the second square, etc. As you can see, the decoded grid says, "YOUR MIND IS THE KEY."

I would only add to Karly's interpretation that Russian is used in the anagram of Nola Kaye, and James Sanborn has done two additional sculptures involving the Russian alphabet. The Russian coat-of-arms shares the crowned double headed eagle with the 33rd Scottish Rite Scottish Masons! Knowing Dan Brown's love for art and architecture, can all this be pointing to a novel that takes place in St. Petersburg with its extraordinary Hermitage Museum?

Does everything on the cover mean something? Even the ISBN number has not escaped attention. If you remove the initial 978 then the remaining numbers 0+3+8+5+5+0= 4+2+2=5 = 34. The number 34 is the sum of the numbers in Dürer's magic square. I am certain this is just the beginning.

Links:

GREG TAYLOR CODES ON THE COVE
thecryptex.com/features/codes-on-the-lost-symbol-cover

THE LOST SYMBOL FRONT COVER
dailygrail.com/share/lostsymbolcovers/bookfront.jpg

ON THE ISBN NUMBER
roman-numerals.inrebus.com/2009/09/the-lost-symbol---decoding-the-isbn.html

V

LOST AND FOUND SCIENCE

> ⊓⊏⊔ ⊏∨ >∨ ← ⊐⊔⊏ ⊔

In his interview with *NBC Dateline* in October 2009 Dan Brown admitted: "Noetic science really is the reason this book took me so long to write. . . . I've said before I'm a skeptic. And I hear about these experiments that are being done that categorically and scientifically prove that the human mind has power over matter. . . . I spent a lot of time researching Noetic science and really had to get to the point where I realized, 'You know what? The world's a stranger place then we thought.' And the human mind really does have the ability to affect matter."

But the fascination with science and the conflict of the scientific and spiritual were already well apparent in earlier works. In his London trial Brown recalled:

I began reading books on science and religion, including *The God Particle, The Tao of Physics, The Physics of Immortality, The Quark and the Jaguar,* and others. The recurring theme that excited me was the idea that science and religion were now dabbling in common areas. These two ancient enemies were starting to find

shared ground, and CERN was at the forefront of that research. This was how I ended up writing *Angels & Demons*—a science vs. religion thriller set within a Swiss physics laboratory and Vatican City. The grey area that interested me was the ongoing battle between science and religion, and the faint hope of reconciliation between the two. This was my "big idea" and my "grey area."

Dan Brown's new novel is an attempt to find a way to reconcile the gap between science and religion, between the world that we perceive through our senses and the world of the spirit or beyond our vision or touch. What many may call the New World Order, a new revelation or enlightenment, is in fact as old as recorded history itself. The separation of scientist, philosopher, and priest is an aspect of our modern world, but an artificial one that learned men and women ignored over the past. We need only to examine the multifaceted writings of Francis Bacon, Isaac Newton, or Benjamin Franklin and Thomas Jefferson (all of whom are cited in *The Lost Symbol*) to realize that the boundaries placed on our knowledge and sensations were ignored by many great thinkers. In the twentieth century, Albert Einstein surprised some by his own utterances on spiritual matters.

The Da Vinci Code gave new life to a number of works that had been published, read, or overlooked and then largely forgotten, such as *Holy Blood, Holy Grail. The Lost Symbol* will surely raise curiosity and interest about a number of topics and institutions that, while new to most readers, have actually been in existence for at least thirty years. The entire realm of parapsychology and New Age wisdom is likely to see increased interest in the coming months and years. Brown, who had always been critical of

the religious interference or attempts to stifle scientific thought, seems to have found a synthesis, that area where mind meets matter, where the physical phenomenal world gives way to another spiritual, astral, noumenal world.

Noetics

Noetics, we learn in the book, is "a science so advanced that it no longer resembles science" (34). Critics such as Ray Hyman, who has made a career of trying to debunk the claims of parapsychology, along with the Committee of Skeptical Inquiry, would argue that it isn't science at all.

> The word "noetic" comes from the ancient Greek nous, for which there is no exact equivalent in English. It refers to "inner knowing," a kind of intuitive consciousness—direct and immediate access to knowledge beyond what is available to our normal senses and the power of reason.

That definition is taken from the Institute of Noetic Sciences (IONS), a nonprofit research institute in California. Founded in 1973 by former U.S. astronaut Edgar Mitchell, the Institute is now directed by Marilyn Schlitz, the President of the Institute, who has enjoyed the suggestion that she might be the inspiration or prototype for Katherine Solomon in the novel.

In the person of Katherine, Brown finds a new high priestess, someone committed to exploring human consciousness and harnessing its power. She speaks of "inten-

tion," the ability to focus on consciousness for a purpose: *"This is the missing link between modern science and ancient mysticism"* (57). And this is the essence of the book's message. Mal'akh, Katherine's nephew, who is bent on diabolical transformation and destruction, realizes that his dream will fail if Katherine succeeds. His mission becomes to eradicate her work and keep it from the eyes of the general public.

Brown has apparently not visited the Institute, but he clearly did substantial research on its work and is reported to have sent a flattering e-mail on the day of publication, hoping the Institute would enjoy its newfound attention. That may be the understatement of the year. For the inquisitive, there is ample material to be found provided by the Institute itself on the Internet. The brief explanation is that the Institute seeks to study how our inner world, consciousness, can interact with the outer material world, all with the goal of complete transformation! The Institute lists in bullet-point format its activity that:

• Explores the frontiers of consciousness
• Builds bridges between science and spirit
• Researches subtle energies and the powers of healing
• Inquires into the science of love, forgiveness, and gratitude
• Studies the effects of conscious and compassionate intention
• Seeks to understand the basis of prevailing worldviews
• Practices freedom of thought and freedom of spirit

And Marilyn and Katherine? Marilyn is quoted as believing she is the character of Katherine. "Waking up one morning to find yourself a fictional character in a bestselling novel has taken a little adjusting to." Despite physical differences, Marilyn found much in common. "Like Katherine, Schlitz's father and brother were 32nd degree Masons and members of the Scottish Rite. Both women started their

logo for The Institute of Noetic Sciences

careers at nineteen, studied distant intention, prayer, and healing, and both believe ancient wisdom traditions predicted discoveries in modern science."

Schlitz says she can identify ten experiments by her Institute in *The Lost Symbol*. But she says, "There's a lot of science fiction in the book."

Links:
THE INSTITUTE OF NOETIC SCIENCE
www.noetic.org and
www.noetic.org/about/godeeper.cfm

WHAT ARE NOETIC SCIENCES
www.noetic.org/publications/review/issue47/r47_Harman.html

COMMITTEE OF SKEPTICAL INQUIRY
www.csicop.org

MARILYN SCHLITZ
http://www.youtube.com/watch?v=G6Vo4HHadJs

NPR WOMAN READS DAN BROWN'S NOVEL, DISCOVERS SELF.
www.npr.org/templates/story/story.php?storyId=113676181

THE SECRET: THE LAW OF ATTRACTION
www.youtube.com/watch?v=7CbIsTg59B8&feature=related

The Field and The Intention Experiment

Another contender for the inspiration of Katherine Solomon has to be Lynne McTaggart. She is the author of two key works, including one mentioned in the novel, *The Intention Experiment*. McTaggart lives in London, but she travels the world on a mission to channel the energies of human minds for the improvement of the lot of humanity. She and her husband began in the field of alternative medicine, publishing works such as *What Doctors Don't Tell You: The Truth About The Dangers Of Modern Medicine* (1999) and *The Cancer Handbook: What's Really Working* (2000). This London-based writer began exploring the work of the Princeton Engineering Anomalies Resaerch Lab (PEAR) and the Stanford Center for the Advanced Study in the Behavioral Sciences, and this ultimately led to the publication of *The Field*.

Dan Brown introduces Katherine Solomon's study of *"human consciousness,* as Noetic author Lynne McTaggart described it, a substance *outside* the confines of the body . . . highly ordered energy capable of changing the physical world. Katherine had been fascinated by McTaggart's

book *The Intention Experiment*, and her global, Web-based study—theintentionexperiment.com—aimed at discovering how human intention could affect the world" (56).

McTaggart's *The Field* refers to a concept in quantum physics in which exists the least possible energy, i.e., it holds no physical particles or matter. This is called the Zero-Point Field. Nonetheless electromagnetic waves and particles appear to spring up on their own. *The Field* is appropriately subtitled: *The Quest for the Secret Force of the Universe.* She examines the history of research that has grown from the field of quantum physics to impact further research in a broad number of areas where the old dictum "mind over matter" becomes more like "mind determines matter." The basis is that an energy field, an independent energy field, exists and that we can all collectively tap into that field with our consciousness. That ability is used to explain paranormal activity that is otherwise inexplicable, such as remote healing and telekinesis (the art of moving an object by thought).

McTaggart's research involved scores of experiments and references leading physicists who inform this field of parapsychology. They include many of the scientific names in the novel, beginning with Werner Heisenberg, creator of this field of quantum mechanics and author of the "uncertainty principle." McTaggart moves forward in time to the 1970s and up to the present to PEAR, IONS, Stanford, Copenhagen, etc. It is interesting that she notes that many of these individuals, respected researchers with scholarly credentials, "were philosophers as well as scientists" (*The Field*, 224). The new physics asserts: "The communication of the world did not occur in the visible realm of Newton, but in the subatomic world of Werner Heisenberg" (225). It is not clear that Langdon or Brown's readers can comprehend this. Clearly this an an appeal to something found that

was presumably intuited by the Ancients. This key to the unity of all matter and energy is the syncretic solution that the novel offers its readers. But ultimately such a solution has to be believed in, rather than known. This is not as revolutionary as it seems but simply leads us back to our early beginnings. This is the point where faith engages what the mind can no longer comprehend.

If *The Field* was the research that led to McTaggart's belief system, *The Intention Experiment* is her own attempt to demonstrate and use the power of collective consciousness to impact the physical world. This is more than a book; it crosses the lines between the print world and the virtual world: "This is a book without an ending. . . . *The Intention Experiment* is the first 'living' book in three dimensions" (xxi).

Most of the book is focused on recapping some of the research done in numerous fields, including remote healing, plant telepathy, mental mastery of metabolism, mind-body therapies, etc. The book also provides a method to enable the individual to tap into her or his own human potential, and then to be involved in a broader experiment. Readers are invited to participate in the experiment harnessing human consciousness and focused attention by signing onto the website. Noteworthy is an announcement that the website will periodically require the reader to examine the book for a password to unlock the access to the work itself. This is not unlike Dan Brown's embedding within his text information needed for deciphering messages. Readers have been invited to join in the project and the number of participants has grown dramatically since the publication of the novel.

While much of this is new, Brown's faithful readers will recall his fascination with the Large Hadron Collider built by the European Organization for Nuclear Research (CERN) and the work of Vittoria Vetra in *Angels & Demons*

on "entanglement" and antimatter. Is it just a coincidence that they are at the center of this seventeen-mile circumference of the particle accelerator, not unlike the point in the circle that forms the circumpunct?

Front book cover of The Intention Experiment

Used by permission of Getty Images/Free Press

Links:

WHAT THE DOCTORS DON'T TELL YOU
www.wddty.com

THE FIELD
livingthefield.ning.com

THE INTENTION EXPERIMENT
www.theintentionexperiment.com

LYNNE MCTAGGART ON *NBC DATELINE*
www.msnbc.msn.com/id/21134540/vp/33350056#33350056

INTERVIEW WITH LYNNE MCTAGGART
www.youtube.com/watch?v=8dUsRWs-pZY

The Smithsonian Museum Support Center

"Nobody knows this place is here" (33). One more "Fact" that Brown lists sandwiched between the Office of Security and the Institute of Noetic Sciences. Yes, there is an SMSC, the Smithsonian Museum Support Center, located at 4210 Silver Hill Road, Maryland 20746-2863, some seven miles from the U.S. Capitol. "The world's largest and most technologically advanced museum is also one of the world's best secret" (21). Well, it isn't a secret any longer, Mr. Brown! Katherine works here in a laboratory specially constructed by her brother for her research. Since it is located outside of Washington, D.C., Robert Langdon's journey does not bring him here. Mal'akh will drive here bent on destruction of Katherine's work and will attempt to burn the facility down. Luckily there was no fire in real life.

The Smithsonian provides ample information on its own website that describes the facility, its history, and the collection. Brown mixes fantasy and fiction to create a very chilling place indeed. Katherine's laboratory and research data are here in Pod 5 and Katherine's assistant, Trish Dunne, will be murdered in Pod 3, the "wet pod." The fic-

tion is based on some fact, although the assertion that her Noetics lab is unlike any other in the world might be questioned. The mysterious Pod 5 where Katherine works has already become the new "wet pod" and houses a collection of 25 million specimens. The old Pod 3 (wet pod) is being renovated to hold works of art. In all, the Support Center has over 54 million items. They include the striking list of items that Brown documents. The center opened in 1983 and is not so much a museum as it is a research facility and library. While scholars and researchers may use the facilities, it is not open to the general public simply seeking to satisfy their curiosity.

LINKS:

SMITHSONIAN FACT SHEET
newsdesk.si.edu/factsheets/msc_factsheet2009.htm

"SMITHSONIAN REVEALS ITS HIDDEN TREASURES"
www.washingtontimes.com/news/2007/aug/16/smithsonian-reveals32its-hidden-treasures

"SMITHSONIAN TREASURES, BEHIND THE SCENES"
articles.latimes.com/2004/oct/20/entertainment/et-smithsonian20

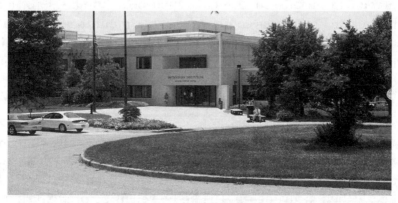

Photo by Chip Clark.

Smithsonian Museum Support Center entrance

Weighing the Soul and
Total Liquid Ventilation

Two of the more surprising topics in the novel are the revelations that the soul can be weighed and that humans can survive with liquid in their lungs. The first discovery described by Katherine is offered as proof of something physical and material, proof of the existence of an inner substance that survives after death.

Katherine when threatened with imminent death at the hands of Mal'akh raises the age old question: *"What happens when we die?"* (391). She and her brother Peter had previously discussed the existence of a human soul, and Katherine had prepared her own experiment to substantiate their belief that they did possess "a particle of God." Katherine proceeds in her thought from the Book of Genesis to Noetic Science to hypothesize that the soul, this spiritual intelligence, might be "thought," something that Noetic science concludes has mass. "Can I weigh a human soul?"(392). To carry out her experiment she develops an adult-size sleeping pod that incorporates high precision microbalance. Her dying science teacher from Yale agrees to be weighed at his death. His body weight before expiring is

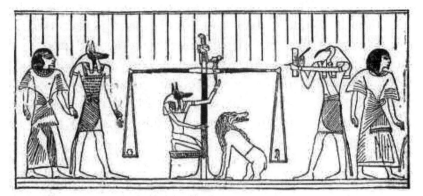

Egyptian weighing of the soul

51.5453544 kg. After his passing, and as the experiment progressed, the man became lighter. Peter and Katherine succeed in weighing the human soul. Overcome by emotion as they are witnessing the one death, Peter recalls his son Zachary. Just at the instant in Katherine's thought or memory, Mal'akh, the still unrecognized Zachary, wheels Peter into his brutal torture chamber. In this moment of high suspense we never learn the weight of the "soul."

A version of this "look for the truth" appeared in the 2003 film starring Sean Penn, entitled *21 Grams*. Perhaps that is the weight of the human soul? This is a seemingly new idea, for as Katherine laments: "The existence of the human soul . . .was probably a concept that would never be scientifically proven" (392). But in fact history records just such an attempt over 100 years ago. In 1907 Dr. Duncan MacDougall of Haverhill, Massachusetts, carried out a similar experiment. His work is recounted in a book by Robert L. Park, *Superstition: Belief in the Age of Science,* and described in detail on the Internet. Dr. MacDougall also constructed a special bed "arranged on a light framework built upon very delicately balanced platform beam scales." He had six terminally ill patients and recorded that after the

death of one: "The loss was ascertained to be three fourths of an ounce." When he weighed fifteen dogs and recorded no loss after death, he was confident that dogs did not have souls. The results were published in *The New York Times* and *American Medicine* over a century ago. The three quarters of an ounce, or approximately 21 grams, has reappeared in the twenty-first century unchallenged by any verifiable research.

The other concept in *The Lost Symbol* is connected with dying is Total Liquid Ventilation. Robert Langdon is enclosed in a capsule into which Mal'akh pumps a liquid. Robert, we know, is terrified of closed spaces and appears to be drowning. We, the readers, assume that he really has died. But Langdon miraculously survives. He is risen from the clutches of death to survive and to continue meeting the challenges of this novel, and his readers hope of many more. The cunning Mal'akh had used not water to drown him, but rather *"oxygenated fluorocarbons"*(412). With a captive audience Brown gives us a brief historical survey of "liquid breathing" that he dates to a 1966 experiment on a mouse, and in the 1989 movie *The Abyss*. Director Sato recalls some U.S. Navy and U.S Air Force experimentation as well as the chilling thought that in addition to New Age meditation tanks, the substance might be used to induce the sense of drowning in the horror of water boarding for interrogation. Brown's fear of technology turned to evil uses seems well justified.

While work continues on finding ways to use oxygen-infused fluorocarbons, in medical use there appear to be no real-world abilities for it to sustain life at this time.

Links:

21 GRAMS TRAILER
us.imdb.com/video/screenplay/vi3383951641

WEIGHING THE SOUL
www.snopes.com/religion/soulweight.asp

KARL S. KRUSZELNICKI, "21 GRAMS"
www.abc.net.au/science/articles/2004/05/13/1105956.htm

FUTURE TECH: HERE, BREATHE THIS LIQUID
web.archive.org/web/20080119132718/http://www.skyaid.o
rg/Skyaid+Org/Medical/Heart_Cool_Oxygen.htm

TOTAL LIQUID VENTILATION PROVIDES ULTRA-FAST
CARDIOPROTECTIVE COOLING
www.journals.elsevierhealth.com/periodicals/jac/article/PII
S0735109706028609/abstract

Modern-Day Science

The Lost Symbol is up to date on twenty-first century technology and scientific advancement. Brown refers to Noetics and the Living Experiment. The work of Katherine Solomon is supposed to take place in a secret lab in the SMSC, dedicated to the study of human consciousness acting on physical matter. The novel refers to other scientific and scholarly figures and sources to lend authority to those claims. Much of this emanates from the field of quantum physics, the science that looks at subatomic particles and the energy field that has been observed and governed by the uncertainty principle first articulated by Heisenberg.

While this world seems to be diametrically opposed to the world of Newton or the explanation of Albert Einstein that all matter and energy exist in some equilibrium, it is equally fascinating to examine Einstein's own theories of the place of the spiritual in our life. The Dean of the National Cathedral quotes him to Katherine and Robert:

> That which is impenetrable to us really exists. Behind the secrets of nature remains something subtle, intangible, and inexplicable. Veneration for this force beyond anything that we can comprehend is my religion (308).

Einstein lived and worked in Princeton, one possible explanation why Brown selected that university for Robert Langdon's *alma mater*. In one more growing set of interconnections the Albert Einstein Monument on Constitution Avenue, within sight of Washington Monument, holds an astrological secret. On the star map at the statue's granite base, there are more than 2,700 metal studs embedded, representing the planets, sun, moon, stars, and other celestial objects. They were precisely positioned by astronomers from the U.S. Naval Observatory to correspond to the position of the planets on the memorial's dedication date.

Science and technology figure prominently in this novel of the digital age. Blackberry devices as well as portable computers that access the Internet and utilize search engines are predominately displayed. The ultimate threat to national security is a video of prominent political

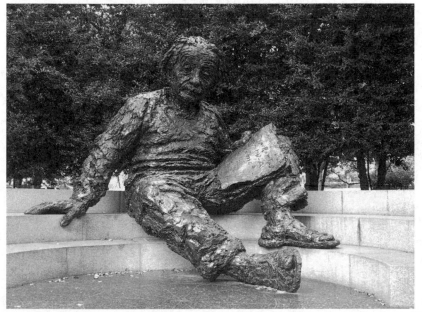

Photo by Dan Smith.

Albert Einstein Memorial Statue, by Robert Berks, in Washington, D.C.

figures participating in a Masonic ritual. To provide this information to the media takes several minutes. For an audience of readers, some of this may come as new. But the hundreds of millions of user of YouTube or CNN iReport know that uploading a video is as simple as child's play. And in spite of Director Sato's attempts supported by the leading technological experts of the CIA, YouTube and GoogleVideo already have dozens of videos purporting to be recordings of secret Masonic sessions. The real danger here is that we will be so inundated with materials that we will be unable to separate any real fact from fiction.

The Internet is also an integral part of the work—both internally and externally. Brown and his publisher seem to revel in the seamless travel between reality and virtual reality that blurs the distinction between both. The electronic world of webpages, quests, tweets and wall posts guarantees to keep the novel close at hand.

Links:

QUANTUM PHYSICS. WERNER HEISENBERG
www.spaceandmotion.com/physics-quantum-mechanics-werner-heisenberg.htm

SECRET HISTORY OF THE FREEMASONS VIDEO
www.youtube.com/watch?v=Pa-mdPb77K0&feature=related

VI:
FREEMASONRY

> ∏◻∟ ⊏∨ >∨ ← ⊐⊔⊏ ∟

From the very beginning, this was a novel planned around Freemasonry. Dan Brown explicitly stated his intention when he spoke of his next novel after the publication of *The Da Vinci Code*. During my own visits to the House of the Temple in Washington, D.C. and the George Washington Masonic Memorial in Alexandria, Virginia, Freemason guides spoke with pride of the fact that Brown had visited and made use of the research opportunities in both places. Both appear in the novel, although the magnificent Alexandrian tribute to Washington is used only as a decoy by Robert and Katherine. In an October 16, 2009 interview on *NBC Dateline*, the Temple Room of the House of the Temple was used for parts of the taped conversation between Matt Lauer and Dan Brown. Dan Brown is not a Mason, nor is Robert Langdon, who explains that, for the same reason Socrates was not a participant in the Eleusinian Mysteries, "he had decided not to be initiated; the order's vows of secrecy would prevent him from discussing Freemasonry with his students" (103).

The cover of *The Da Vinci Code* had embedded on it the phrase "Is there no help for the widow's son." The

American cover of *The Lost Symbol* shows the seal of the 33rd degree of The Ancient and Accepted Scottish Rite, Southern Jurisdiction. Langdon is no stranger to societies cloaked in secrecy and mystery to outsiders. The Illuminati, the Knights Templar, the Rosicrucians, and Opus Dei have all appeared in previous novels. In *The Lost Symbol* the Masons are represented by Peter Solomon, The Supreme Worshipful Master, who is a 33rd degree Mason. Mal'akh accepts initiation into Freemasonry as a way to find the Masonic Pyramid, the Lost Symbol or the Lost Word. Ironically Mal'akh as Zachary had rejected the initial invitation of his father, Peter, to become closer acquainted with the secrets of Freemasonry.

The Prologue opens with a description of a Masonic ritual, and Masonic influences are woven throughout the novel. There are repeated references to the Ancient Mysteries and the Egyptians and to the classical Greco-Roman and Judeo-Christian traditions that permeate and inform Freemasonry. We are told of the Masonic role in the creation of Washington, D.C., and the parts played by prominent Masons, including George Washington's laying of the Capitol cornerstone. The resolution of the novel comes with the discovery of the Masonic Bible enclosed in the cornerstone of the Washington Monument. The attempt to keep secret the involvement of leading public figures in a Masonic ceremony is portrayed as a matter of national security, grave enough to involve the CIA. And the entire novel can be read as an allegorical initiation of Robert Langdon and the readers into the world of Freemasonry.

When Brown mentions as "Fact" that the Freemasons are a real organization, he overstates the obvious for the millions of Masons living in the Untied States or abroad. In the italics he so loves, he declares: *"There is a hidden world behind the one we all see. For all of us"*

(465). Furthermore we are told that the Masons are not a secret society, but a society with secrets. In the modern world this is only partly true. Whoever wishes to learn the truth about Freemasonry will be welcomed to their temples, where Masons speak openly of their heritage, their traditions, and their organizations. But they do reserve to themselves the once-secret initiation rights that provide guidance to the symbols that are present in their lodges, aprons, etc. These secrets have long been available in print media and more recently on the Internet. While I will provide links to some of that material, I will, like Brown, try to respect some of the secrets from prying eyes. Brown has said: "I intended this book as a reverential look at their philosophy." My own work reflects, I hope, no less respect for Freemasonry.

Links:

A PAGE ABOUT FREEMASONRY
web.mit.edu/dryfoo/Masonry

THE SUPREME COUNCIL, ANCIENT AND ACCEPTED SCOTTISH RITE, SOUTHERN JURISDICTION
www.srmason-sj.org

FREEMASONRY
www.freemasonry.org

ALBERT MACKEY, *HISTORY OF FREEMASONRY*
www.freemasons-freemasonry.com/mackeyfr.html

Origins

Separating facts from fiction concerning the Masons is no easy task. The historical record indicates that in 1717 in London four lodges came together and formed the Grand Lodge, the basis of Freemasonry today. A *Book of Constitutions* was published in 1723. Earlier references to Masons occur in England and Scotland in the sixteenth and seventeeth centuries, but that predates the recorded history and is the place where legend mixes with actual events.

Langdon offers his students a mini-lecture on the Masons, quoting the standard definition of one of the world's oldest and largest brotherhoods: "Masonry is a system of morality, veiled in allegory and illustrated by symbols" (31). Masons seek to establish an unbroken line from King Solomon and Hiram Abif, the legendary architect of the Temple of Solomon. Stonemasons had existed for centuries and in Europe throughout the Middle Ages they built the grand cathedrals. They held a great secret knowledge—how to lay the keystone of an arch so that it would not collapse. These masons were organized into guilds, and much like trade unions today, they protected their membership by guaranteeing a certain exclusivity. Apprentices worked to learn the craft and become master masons, who in turn

mentored and initiated the next generation. Since masons moved to wherever there was work to be done, they developed a set of verbal signs and gestures that would permit one mason to recognize and validate one another. These "operative" stonemasons and their guilds gave an organizational impulse to the "speculative" masons, who emerge perhaps as early as the sixteenth century, but who are no longer necessarily the craftsmen of yore. These "free" Masons consisted of groups of men coming together to read and discuss the texts of the day, among them the esoteric writings, works on alchemy and astrology, Biblical texts and interpretations, non-canonical books, and legends of the Bible. Many key writers and works would make themselves known in English translation, including the work of the Rosicrucians. Slowly these new "masons" begin to construct elaborate connections, from the Egyptian pyramid builders to Solomon and his Temple, to the Crusades when the Knights Templar supposedly discovered the Temple and its secret in Jerusalem. When the Templars were dissolved and dispersed throughout Europe, according to legend some came to Scotland to build Rosslyn Chapel that was featured in *The Da Vinci Code*.

So the Masons have two traditions: One is related back to the craft of the stonemasons, best symbolized in the well-known Masonic symbol of the square and the compass, and the capital letter "G" for "Geometry" and for God. The other is the esoteric and occult traditions coming from the Ancients and Solomon's Temple that are reflected in Temples with their ceremonial rooms, rituals, and symbols.

Masonry is not a religion. But Masons are united by a belief in a higher power, often designated as The Great Architect of the Universe (TGAOTU). Open to men regardless of their religion, the Masonic lodges were, and are, a natural place for men to gather seeking answers to the

Masonic symbol

accursed questions of existence. Who made me? What happens when I die? Or as Mal'akh expresses in the opening pages of the novel and then repeats: *The secret is how to die*"(3). In modern times the Masons sponsor and fund many charitable activities and campaigns that have improved the lives of millions. Is it any surprise then that in the Untied State, a country based on liberty and religious freedom, that the Masons would have enjoyed such popularity?

Masons, however, have generally practiced silence as regards their critics. The very fact that many were members, but some were not, and that the ceremonies of initia-

tion were not publicly open, has led to an enormous amount of misinformation and pure nonsense to be published. And in so many ways simple coincidence is taken as "causality," even when the simple association of people, places, or events would not lead to a conclusion of collusion or secret dealings. Nonetheless, some people love conspiracy theories, and such theories flourish when they go unchallenged. Such is the lot of the Masons, and Brown's important contribution might be to open the eyes of non-Masons and encourage them to explore in greater depth the Masonic beliefs and traditions. Langdon does dismiss the "misinformation about the Masons" that his students, as well as today's readers, can find on the Internet to inform their "surprisingly warped conceptions about the brotherhood" (26). Readers who do decide to study and pursue this topic further should be careful to evaluate the sources and the veracity of the claims in the flood of information they will be exposed to.

Links:

ANTI MASONRY: POINTS OF VIEW
www.masonicinfo.com

PIETRE-STONES: REVIEW OF FREEMASONRY
www.freemasons-freemasonry.com

YORK RITE MASONRY VIDEO
www.youtube.com/watch?v=hwdP2Cf_knA

Rituals and Symbols

Freemasonry is mystical and esoteric by virtue that it teaches a system of morality that it veils in allegory and illustrates by symbols. The symbols and allegories are revealed in the process of initiation for the three degrees. In the journey, an initiate proceeds through the stages of Apprentice Mason to Fellow Craft Mason and finally to Master Mason. All Masons pass through these three degrees, although the different rites have advanced degrees that can range in number from the York Rite to 33 for the Scottish Rite. The path through the various degrees is seen as a movement toward the light and enlightenment. Along the way the candidate is made aware of the symbols of each degree and the stories or allegories containing valuable lessons for a virtuous life.

Brown describes portions of the initial three-stage ritual Mal'akh undergoes in the Prologue: the right sleeve and left pants leg rolled up, a rope noose around the neck, the "cable-tow" (3). All are "real" according to Brown. But the most striking is yet to come. To take the final oath he drinks wine from a skull and pronounces: *"May this wine I now drink become a deadly poison to me . . . should I ever knowingly or willfully violate my oath."* Langdon actually

tells us upon viewing a video of the ritual that this is "The Fifth Libation," described by John Quincy Adams in his *Letters on the Masonic Institution* (437). On the Brown website, he maintains that the ritual is still performed today. But is this, perhaps the most controversial, ceremony "real"? He was asked this directly in the NBC interview:

Matt Lauer: One character is being elevated to the 33rd degree of the Scottish Rite. It's a rather intense ritual. He, he drinks wine, which is to represent blood out of a skull. How much of that is fact and how much of that is fiction?

Dan Brown: Well, this is a real ceremony. The ceremony is described accurately. The fiction comes in as to whether or not it still happens at this moment in history in this room.

Arturo de Hoyos, the Grand Archivist and Grand Historian of the Supreme Council of the Scottish Rite and himself a 33rd-degree Mason, categorically denied the "facts."

Arturo de Hoyos: One of the things that's wrong is on the very first page. We don't perform the 33rd Degree in this building. We don't confer it at night. The candidates to the members are dressed wrong. And the ceremony's wrong.

Brown draws on a ceremony described in the past to create a modern-day fiction. The 33rd degree in the Scottish Rite is an honorary degree. It is generally bestowed in recognition of great service or extraordinary philanthropy. But there is no such "skull and blood" ceremony practiced by the Scottish Rite today, according to a Mason who shed much light on the novel in his blog, Mark Rivera-Koltko. Anti-Masons will continue to republish, often as if it

141

Scottish Rite symbol

were new, the very accounts of "The Fifth Libation" described almost two hundred years ago.

Brown does, however, open our eyes to the phrases and symbols used. He himself has said he had recourse to the Albert Mackey study of Freemasonry. Other sources could have included the famous *Morals and Dogma,* by Albert Pike. One can only hope that like a good teacher, Brown has inspired his readers to explore on their own some of the voluminous literature available.

There are literally dozens of symbols that inform Freemasonry, and here we can barely mention a few that are central to the novel. Several symbols of the Masons and their rituals are richly represented in the Chamber of Reflection that is attached to each lodge, although there is not one in the subbasement of the Capitol. Elements and symbols of alchemy, reminders of our mortality, a human skull and bones and the abbreviation V.I.T.R.I.O.L. are all precisely described by Brown. He also mentions the tracing boards that contain in symbols the story of the three degrees.

The dustcover for the English-language edition in Europe bears the Masonic symbol, the square and compass, and the letter G. The square and compass are, of course, tools of the original operative Masons. But they also relate to

elements of the first degree, Apprentice Mason. That ritual explains that "The three great lights in Masonry are the Holy Bible, Square and Compass. The Holy Bible is given to us as a rule and guide for our faith and practice; the Square, to square our actions, and the Compass to keep us in due bounds with all mankind, but more especially with the brethren. The "G" stands for God, the Deity, and Geometry, the most important of all sciences."

Peter Solomon's right hand bears the ring of the 33rd degree Mason. The elaborate seal of the Scottish Rite is pressed in wax on the American dustcover and portrays a double-headed eagle and crown, a triangle with the number 33, and the phrase *ordo ab chao* (order out of chaos). The Double-Headed Eagle of Lagash was also used in the Byzantine, Holy Roman, and Russian empires and still marks the official coat-of-arms for the Russian Federation, as well as many other nations. The triangle is key to geometry but it also is key to the pyramid that connects back to Egypt, the home of the ancient mysticism presumed to have been passed along to Solomon.

The numbers 3, 13, and 33 are all significant in the Masonic realm. One god, 3 persons, the Trinity. There are 3 initial rites of Masonry. There are three sides to a triangle. The 13 American colonies and 13 original states are well represented on the Great Seal of the United States. There are 13 leaves in the olive branch, 13 bars and stripes in the shield, 13 arrows in the right claw, 13 letters in *E Pluribus Unum*, 13 stars in the green crest above, 13 levels in the pyramid, and 13 letters in *Annuit Coeptis* ("He has favored our undertakings").There are also 13 letters in *The Lost Symbol*. The Eagle has 33 feathers in its left wing. The Scottish Rite has 33 degrees. The Temple has 33 pillars, and they are 33 feet tall. Christ was crucified at the age 33. The human spine has 33 vertebrae. The book was published on

143

09/15/09 = 33. The Prologue begins at 33 minutes after the hour, *The Lost Symbol* has 133 chapters. "In the days of Pythagoras . . . the tradition of *numerology* hailed the number 33 as the highest of all the Master Numbers. It was the most sacred figure, symbolizing divine truth" (332). "'Thirty three" Katherine said, 'is a sacred number in many mystical traditions'"(333). How did Brown get that on page 333? H'mm, that's why this book has 33 Keys and 133 Links!

Links:

LITERATURE ON THE FIFTH LIBATION
www.indianafreemasons.com/imoanti/isittrue/chap5.htm

MEMENTO-MORI
www.freemasons-freemasonry.com/skull-bones.html

33RD DEGREE INITIATION
www.conspiracyarchive.com/NWO/33rd_Initiation.htm

ALBERT MACKEY, *THE ENCYCLOPEDIA OF FREEMASONRY*
www.phoenixmasonry.org/mackeys_encyclopedia

ALBERT PIKE, *MORALS AND DOGMA*
www.freemasons-freemasonry.com/apikefr.html

TRACING BOARDS
www.freemasons-freemasonry.com/TBs.html

MARK KOLTKO-RIVERA, DISCOVERING THE LOST SYMBOL blog
lostsymboltweets.blogspot.com

The Founding Fathers

Ever the teacher, Langdon sets out to acquaint his students with the historical role of Masons in the design and architecture of Washington, D.C., and their symbolic presence in our lives to the present. These are not so much secrets, for they have been on public display for all to see, as they are little known or unknown aspects of familiar people and places. The whirlwind ride through the novel is for the reader not unlike the Masonic search for enlightenment that becomes transformative. Americans recognize the phrase and consider as "Founding Fathers" those leaders in our history books who participated in the events leading up to the American Revolution: The signing of the Declaration of Independence on July 4, 1776. The war with England from 1775–1783. The Peace Treaty of Paris, followed by the drafting and ratification of the Constitution establishing these United States of America. The election of George Washington in 1789 as first president and the construction of Washington as the capital of the new nation. These names are familiar to schoolchildren, but how many were Masons and, more importantly, did that Masonic membership play a decisive role in the founding of the New Republic?

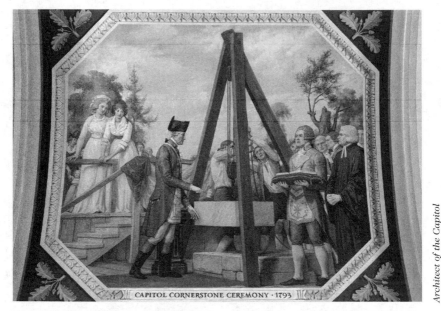

George Washington laying the cornerstone of the Capitol

One of the earliest American Masons was Benjamin Franklin, who republished *The Constitutions of the Freemasons*. Franklin was active in the Masonic lodges of Philadelphia and was one of the drafters of the Declaration of Independence. Franklin was a cosmopolitan man of the world. He spent several years in London and later in Paris. He was knowledgeable, well read, and wrote widely. Many Americans may not be familiar with the extent of his writings, but most know his sayings, such as "God helps those who help themselves." Franklin was present at discussions on planning the U.S. Capitol and was instrumental in the design of the Great Seal of the United States. His likeness appears on the American $100 bill. But was he a Masonic conspiracist?

George Washington was a decorated military campaigner for the Colonial Army when it was under British

control. As Commander in Chief, he would defeat the British, opening the doorway to true American independence. He was elected the first President of the United States, and he who would engage the people most responsible for the creation of the District of Columbia. The spot selected was on land not far from his own beloved Mount Vernon estate in Virginia and would bear his name. Washington appears in *The Lost Symbol* and is artistically represented in the painting *The Apotheosis* and the Greenough bust. His participation in the laying of the Capitol cornerstone is depicted on a painting that Langdon sees. Then there is the Washington Monument, the gavel, and the trowel. The living legacy of our first president is commemorated in the George Washington Masonic Memorial, which, although it serves only as a decoy in the novel, is well worth a visit.

There is one more unmentioned tie between the first and subsequent American Presidents. About to be sworn in in 1789, Washington asked for a Bible for his oath of office, but there was none. General Jacob Morton, the Parade Grand Marshal, retrieved the Bible from St. John's Masonic Lodge #1. Known ever since as the "Washington Bible," it was present at the laying of the cornerstone of the U.S. Capitol building and the dedication of the Washington Monument. In the twentieth century four American presidents used the Washington Bible at their inaugurations: Warren G. Harding, Dwight D. Eisenhower, Jimmy Carter, and George H.W. Bush in 1989.

How many founding fathers were Masons? The Masons and the lodges offered an opportunity for like-minded men to meet away from public scrutiny, much like social fraternal organizations today that attract a sizable number of people. So it was only natural that free-thinking, liberal, intelligent individuals would congregate with one another. Nine of the fifty-six signers of The Declaration of

Independence were Masons. They included John Hancock, famous for his signature (the first and most striking) on the document and the legend that he said: "There, I guess King George will be able to read that!" Thirteen of thirty-three (a perfect Masonic coincidence) signers of the Constitution were Masons, including Franklin and Washington. There was also Daniel Carroll of Maryland, who was present at the cornerstone laying of the Capitol. And even Dan Brown was likely surprised to find that John Langdon of New Hampshire was a signatory, though not a Mason. Thirty-three (that number again) of seventy-four generals in the Continental Army were Masons, including General de Lafayette from France and General Frederick von Steuben from Prussia. Other famous American Masons included Paul Revere, Ethan Allen, John Paul Jones, and Thomas Paine.

But what was the conspiracy? The creation of a New World Order, based on a respect for human liberties and religious freedom? An attempt to insert into the new nation a system of beliefs and morality: "One nation under God, indivisible, with liberty and justice for all"? Does this constitute a two-hundred-year conspiracy that some see as diabolical and others as domination by a selected few in a secret society? It is impossible to prove that no such conspiracy exists, but most reasonable minds will recognize and dismiss such claims as without foundation. But Dan Brown's novel is sure to provoke new interest in many of these ideas.

At the time of the American Revolution and for the first quarter of the nineteenth-century Freemasonry flourished in the United States. But one incident caused long-term harm, the so-called "Morgan Affair." In 1825 William Morgan threatened to publish a book revealing all the secrets of Masonic rituals. There is the threat in the Masonic initiation quoted in *The Lost Symbol* that anyone sharing

the secrets would have: *"Throat cut from ear to ear . . . tongue torn out by its roots . . . bowels taken out and burned . . . scattered to the four winds of heaven . . . heart plucked out and given to the beasts of the field–"* (5). Morgan was arrested and then released, but he disappeared and it was rumored that he had been murdered by Masons. In part this instigated an anti-Masonic movement and even an Anti-Masonic Political Party that backed President John Quincy Adams. The Freemasons would not completely emerge from this cloud of suspicion until after the Civil War. A footnote to the affair is that Morgan's widow became one of the wives of Joseph Smith, Jr., founder of the Church of Jesus Christ of the Latter-day Saints (Mormons), who was reported to have uttered the phrase "Is there no help for the widow's son" just before he was murdered.

Links:

THE MASONIC FOUNDATIONS OF THE UNITED STATES
watch.pair.com/mason.html#fathers

WILLIAM MORGAN, *THE MYSTERIES OF FREE MASONRY*
www.gutenberg.org/files/18136/18136-h/18136-h.htm

Masons in Power

"*This video will create chaos*" (438). In *The Lost Symbol* the threat to the Republic is that certain policymakers in Washington will be identified as Masons and their participation in potentially embarrassing Masonic rituals will be made public. Moreover a video documenting secret Masonic rituals will be in the public domain. This is cause for the CIA to engage in a massive cover-up! The italicized fictional list is impressive: Two Supreme Court Justices ... The secretary of defense ... The speaker of the House ... Three prominent senators ... including the majority leader ... The secretary of homeland security ... And ... The director of the CIA." (436). Original capitalization notwithstanding, this grouping is noteworthy. But how powerful and omnipresent are Freemasons today?

Fourteen of forty-four U.S. Presidents have been Masons: George Washington, James Monroe, Andrew Jackson, James Knox Polk, James Buchanan, Andrew Johnson, James Garfield, William McKinley, Theodore Roosevelt, William Howard Taft, Warren G. Harding, Franklin Delano Roosevelt, Harry S Truman, and Gerald R. Ford, Jr. As many as forty of just over one hundred Supreme Court Justices were Masons, but none of the sitting Justices

has been identified as a Freemason. There are no doubt senators, representatives, cabinet officials and governors who are Masons, but I have found no exhaustive list.

Unquestionably the Masons have participated, and continue to participate, in public service, even as there were countless Masons involved with the architecture and planning of D.C. The ritual laying of cornerstones of historical buildings and monuments also attracted Masons—from the White House and the Capitol to the Washington Monument, The Jefferson Memorial, and the House of the Temple. Even non-Masons have used a Masonic Bible in their inaugurations, including George H.W. Bush.

One frequently cited example of Masonic influence is the Great Seal on the U.S. one dollar bill approved by Franklin (Ben Franklin again?) D. Roosevelt in 1935, although the phrase "In God we trust." on all bills and currency not until 1955. Dan Brown does the parlor trick of revealing the letters MASON in the Great Seal on our one-dollar bill and provides a commentary on the unfinished pyramid. The topic is also mentioned in *Angels & Demons*. But dozens of others have written about his, including Manly P. Hall and David Ovason.

Inoue Sato (shades of Senator Dan Inouye of Hawaii) succeeds in protecting the Masonic secrets. But most Americans might be surprised to learn that Buzz Aldrin, who brought back a moonrock for the National Cathedral, also presented a flag that flew on the moon to the House of the Temple. The House of the Temple also at one time exhibited a re-creation of the office of J. Edgar Hoover, complete with his desk, carpet, and Masonic Bible. Hoover, now largely forgotten, was one of the most powerful Washingtonian figures of the twentieth century as Director of the FBI from 1933 until his death in 1970.

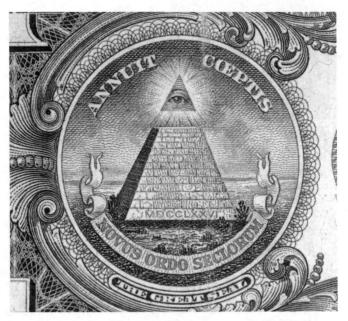

Pyramid with all-seeing eye on one-dollar bill

Conspiracy theorists will always find coincidences to support their claims. But their creation of fiction from simple facts rivals the writing of Dan Brown himself.

Links:
FAMOUS MASONS
www.calodges.org/no406/FAMASONS.HTM

"IN SEARCH OF THE HILL'S FREEMASONS"
www.politico.com/news/stories/0909/27639.html

HOW THE GREAT SEAL GOT ON THE DOLLAR BILL
www.greatseal.com/dollar/hawfdr.html

VII.
THE SECRET TEACHINGS OF ALL AGES

> ∏⊡Ŀ ⊏∨ >∨ ← ∃∪⊏ Ŀ

Dan Brown has used his previous novels to acquaint readers with the Illuminati, the Rosicrucians, the Priory of Sion, the Knights Templar, Opus Dei, and artists and scientists from Bernini to Leonardo da Vinci. None of this has been hidden, or secret or concealed. Whoever wishes to unlock the so-called Secrets of the Ancients need look no further than the nearest library, encyclopedia, or nowadays *Wikipedia*. Brown's greatest contribution may be his ability to identify for his readers curious aspects of our collective human heritage and reveal them anew to our generation. For the past five hundred years at least, men have searched the written historical record that preceded them for answers to the question of our mortality. The invention of the printing press largely coincided with a renewed European interest in the cultures of ancient Greece and Rome, and a new questioning of authority, leading to the Protestant Reformation or revolutions that challenged the power of the Roman Catholic Church.

These all found resonance in a new set of searches and responses based on earlier texts. Brown is well read in this tradition, but unlike *The Da Vinci Code* for which he actually published a bibliography, in *The Lost Symbol* he merely alludes to dozens of individuals or traditions.

The book begins with the epigraph: "To live in the world without becoming aware of the meaning of the world is like wandering about in a great library without touching the books." *(The Secret Teaching of All Ages)*. Brown doesn't identify the author of this classic text from 1928, an attempt by Manly P. Hall to assemble under one cover a description of esoteric thought from the beginning of recorded history. We shall return to that book, but it is clear that Brown is familiar with it and other writings by Hall. What is most notable is that here too the "secret teachings" are not all that secret. But they do lie outside the confines of the traditional religious beliefs and tenets of the Judeo-Christian tradition. Whether these texts were largely ignored, or in some cases banned, most Westerners will find these writings as new today as Hall's audience did in the 1920s.

The difference is that today some of these mysteries are being exposed to millions in an extraordinary number of volumes, whereas some of these earlier texts had far less exposure. In addition to the work of Hall, Albert Pike, Grandmaster of the 33rd Degree Scottish Right of Freemasons, wrote a legendary compendium, *Morals and Dogma*, that referenced hundreds of names extending back to earlier Egyptian and Classical civilizations.

Interested readers can make their own list, of course, and we shall try to examine in some detail the

specifics of the Middle Ages through the Invisible College, the Hermetic tradition along with Hall's contribution to the Ancient Mysteries, and finally the Bible. Many of the key writings are available in the Internet Sacred Text Archive.

Links:

INTERNET SACRED TEXT ARCHIV
www.sacred-texts.com

"The Invisible College"

The Invisible College is among the organizations that Brown lists under his heading "Fact" as one that exists. One might question the use of the present tense. The historical Invisible College is considered the legitimate birthplace of the British Royal Society as recounted by Robert Lomas, in his book *The Invisible College: The Royal Society, Freemasonary and the Birth of Modern Science (2002)*. In the 1640s a group of philosopher-scientists gathered to discuss, among others, the writings of Sir Francis Bacon. This informal group included Christopher Wren, the architect of St. Paul's Cathedral in London, and Robert Boyle, known for Boyle's law on the relationship between temperature and the volume of gases. In 1662 it would become the Royal Society, an organization that continues to exist in London today. One of the members and presidents in the eighteenth century was Sir Isaac Newton, who also makes an appearance after the Dürer magic square is decoded in *The Lost Symbol*.

According to Langdon, the Ancient Mystery Schools of Egypt had passed knowledge along through the centuries that was ultimately "entrusted to an elite group of scientists" (127). He then rushes through past history to merge

the Royal Society and the Invisible College and list among its members Isaac Newton, Francis Bacon, Robert Boyle, and even Benjamin Franklin. Modern "fellows" include Einstein, Hawking, Bohr, and Celsius (128). Langdon at first glance seems oblivious to time. Bacon died in 1626, Boyle in 1691. Newton wasn't born until after Bacon died and he died in 1727, when Franklin was only twenty-one, although he had gone to London when he was seventeen. Albert Einstein, Stephen Hawking, and Niels Bohr were all twentieth century physicists, but Anders Celsius (1701–1744) was an eighteenth-century contemporary of Newton and Franklin. The mention of his name out of order might be significant. Does the association of his famous temperature scale point to a hidden clue concerning the Newton Scale, where the boiling point is 33 degrees?

Langdon's comments notwithstanding, there is no indication that the "Invisible College," a term apparently first used by Boyle in a letter, continued outside of, or parallel to, the Royal Society. Any group of individuals meeting to exchange information, to engage in the life of the mind, might decide to call themselves an "invisible college." The Internet reveals that some have already done so.

Brown is likely more interested in the connections of such individuals to the occult or esoteric tradition that are numerous. Sir Francis Bacon (1561–1626), a statesman, scientist, and philosopher, articulated the so-called Baconian or scientific method in his *Novum Organum* in 1620. He was also largely responsible for editing the famous King James Bible, the English translation still widely regarded as a masterpiece of the language. He authored *The New Atlantis* which introduced a utopian state that some have argued laid the foundation for a more perfect union and that influenced the American founding fathers: "The Utopian vision on which the

Sir Francis Bacon, by *Sir Isaac Newton, by*
John Vanderbank (1731) *Godfrey Kneller (1689)*

American forefathers had allegedly modeled a new world based on ancient knowledge" (272). Coincidentally, the educational institute or college of the island is called Salomon's House. Bacon also supported the settlement of colonies in the Americas.

This is where historical fact ends and speculation begins. Some have argued that Bacon actually was the author of the works of Shakespeare. Others have identified in him a Rosicrucian. In the novel Dean Galloway reinforces the legend that Bacon could have been the Rosicrucian Christian Morgenstern (321). Still others claimed that he did not die in 1626, but simply vanished and moved to the European continent. One group proclaims him as one of the Ascended Masters, a keeper of the Secret

Mysteries. Langdon claims that Bacon was a Rosicrucian who penned *The Wisdom of the Ancients* (490). Manly Hall explicitly connects Bacon to the origins of modern-day Freemasonry:

> Sir Francis Bacon was a link in that great chain of minds which has perpetuated the secret doctrine of antiquity from its beginning. This secret doctrine is concealed in his cryptic writings (*Secret Teachings,* 549).

We see one more reason for the fascination of Brown for Bacon: the connection with his ciphers, including the Baconian cipher that appeared in *The Da Vinci Code*. All of this is speculation concerning Bacon rejected by most respected historians of the Masons, who simply do not accept it as demonstrable fact. But the fiction prevails.

There is a line that connects Bacon and Isaac Newton. Thomas Jefferson considered them two of the three most brilliant men of all time. Langdon calls Newton "an alchemist, a member of the Royal Society of London, a Rosicrucian" (322). Sir Isaac Newton was the president of the Royal Society and Langdon compares his impact to that of Albert Einstein. But his writings also reveal an interest in alchemy, religion, and philosophy. Like Bacon, Newton did extensive work on the Bible, including an interpretation of the complex Book of Revelations, The Apocalypse, that is mentioned in the novel.

Bacon, Newton, and Franklin lived in a far less complicated world, where the collected printed wisdom was still of a reasonable size and scope for intelligent men to peruse and master. The distinction between scholar and scientist had not yet taken hold. A wise man knew lots about many subjects. Spiritual and scientific texts graced a single bookshelf. In the twentieth century the split had already occurred both in the amount of material and the necessity

to specialize to master a subject. So it is all the more surprising to many that the brilliant physicist Albert Einstein was interested in matters spiritual and has several published comments on the mystical. The belief that there must be a reconciliation of the branches of knowledge is a major theme of the novel expressed in Katherine Solomon's quest: "to use advanced science to rediscover the lost wisdom of the ancients" (60).

Links:

HISTORY OF THE ROYAL SOCIETY
royalsociety.org/page.asp?id=2176

The Hermetic Tradition
and Manly Hall

Matt Lauer remarked on *NBC Dateline*: "You might think the symbols came from Mal'akh's twisted mind. They came instead from a mysterious book called *The Secret Teachings of All Ages,* a favorite of Mal'akh's creator, Dan Brown." Brown replied: "And that really is a core book for a lot of what I research and a lot of what I believe." Katherine recalls along with Newton, then Ptolemy and Pythagoras, "Hermes Trismegistus. *Nobody reads that stuff anymore*" (58). Earlier Langdon had heard the words from Mal'akh that echo "an ancient Hermetic adage....As above, so below" (39). The phrase is duly inscribed on the back of the dustcover. *The Lost Symbol* is replete with concepts known as Hermeticism. Hermes Trismegistus (Thrice Great) embodies a combination of the Greek god, Hermes, and the Egyptian Thoth, two traditions united in one. In the Middle Ages and Renaissance that figure gains popularity, in part because of the publication of the *Emerald Tablet*, with one edition prepared in English by Sir Isaac Newton. The document is supposed to hold the secret of alchemy, the key to transformation—and the claim, "That which is below is as

that which is above, and that which is above is as that which is below, to do the miracles of one only thing." This concept of transformation also attracted Manly Hall who devoted an entire chapter to Hermeticism which can basically be summarized as an alternative to the traditional religious approaches to salvation and afterlife. For the hermeticist, the secret is the Key to Immortality inscribed in *The Book of Thoth* and entrusted to the Master of the Mysteries. The *Corpus Hermeticum* that was translated into English as early as 1650 proclaims: "For it is possible, my son, that a man's soul should be made like to God, e'en while it still is in a body, if it doth contemplate the Beauty of the Good." This quote corresponds to the philosophy of life articulated by Peter Solomon to Langdon. And this same central Hermetic text speaks of the light and the word, two recurring images in *The Lost Symbol*: "out of the Light . . . a Holy Word (*Logos*) descended on that Nature."

The reasoning is essentially circular. *The Lost Symbol* or the quest for it is to find the Word, the Lost Word. But when the Word is discovered, it is only a symbol for another Word. "Robert, the Lost Word is not a 'word' . . . We only call it the 'Word' because that's what the ancients called it . . . in the beginning (486).

Perhaps no one in the twentieth century did more for the study of the esoteric Word, to the key to finding it, than Manly Palmer Hall. Born in 1901, he was a prolific American author and mystic. He is perhaps most famous for his 1928 work *The Secret Teaching of All Ages: An Encyclopedic Outline of Masonic, Hermetic, Qabbalistic and Rosicrucian Symbolical Philosophy*. This is the book that Brown cites in his epilogue, and its contents provide the basis for the Hand of Mysteries and even for the major themes of human enlightenment and apotheosis. Hall reprinted and introduced Bacon's *The New Atlantis*. He also published

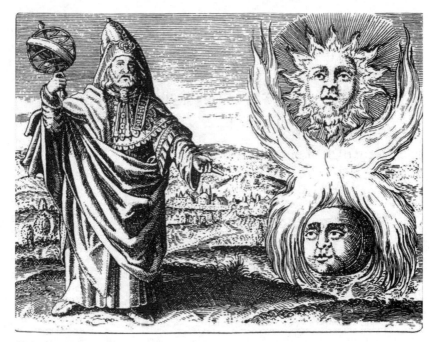

Trismegistus

over 150 books, including *The Lost Keys of Freemasonry,
The Secret of Hiram Abiff,* and *The Secret Destiny of
America.* He was the founder of the Philosophical Research
Society which continues his work today. His own definiton
of philosophy and its mission was "to establish the relation
of manifested things to their invisible ultimate cause or
nature." There is little doubt that Hall served as a primary
source for much in the novel, from the themes of transfor-
mation and enlightenment to the historical figures and the
rich symbolism. It is quite likely that *The Lost Symbol* will
give newfound life to Hall's life and work.

Links:

"THE EMERALD TABLET"
www.sacred-texts.com/alc/emerald.htm

The Secret Teachings

Manly P. Hall, *The Secret Teachings of All Ages*
www.sacred-texts.com/eso/sta

Mitch Horowitz, "The Inscrutable Manly P. Hall"
www.mitchhorowitz.com/manly-p-hall.html

Corpus Hermeticum
sacred-texts.com/gno/th2/th202.htm

The Bible

"*Robert, buried within the hollow cornerstone of this monument, our forefathers placed a single copy of the Word—the Bible—which waits in darkness at the foot of the staircase.*" (488). Like so many surprises in the novel, this one had been hinted at so much earlier. Upon entering the Library of Congress, Langdon passes the display case with the Giant Bible of Mainz, one of three existing original Gutenberg Bibles (181). The Akedah knife, both in Masonic rituals and in Mal'akh's planned mystery play, is intended to re-enact the Biblical scene of the "*most august gift ever offered to God . . . the submission of Abraham to the volitions of the supreme being by proffering Isaac, his firstborn.*" (445). The Book of Genesis 22, recounts the sacrifice of Abram, who had been renamed Abraham by God himself. The story inspires Zachary, renamed Mal'akh, to force his own father, Peter, to transform him into a sacrificial lamb. The Covenant between God and Abraham, the promise of father to son, is distorted in Zachary/Mal'Akh/Abaddon's evil mind. The Covenant of the Old Testament gives way to the new: "*In the beginning was the Word*"(487). Brown, I suspect, hopes that his readers will recall, or look up, the remainder of the passage from the Gospel of John I:

and the Word was with God, and the Word was God. The same was in the beginning with God. All things were made by him; and without him was not any thing made that was made. In him was life; and the life was the light of men. And the light shineth in darkness; and the darkness comprehended it not.

The ultimate secret, the Word, buried and now found is the Masonic Bible buried in the cornerstone of the Washington Monument in 1848. The Masonic Bible combines the Old and New Testaments, along with facts on Freemasonry which itself draws heavily on a number of traditions while tracing its origins to Solomon's Temple. Perhaps not since Dostoevsky, who in the novel is dismissed as reading material for the elite at Yale, has an author imparted to his text such explicit biblical references. From Genesis and the creation of the world, we encounter the selection of the Jews as God's chosen people. Peter Solomon takes up a knife to slay his son before a miraculous intervention. The Solomon father and son embody richly symbolic Old and New Testament associations: from King Solomon and Solomon's temple, the foundation of the modern Masonic legend, to the Apostle Peter in Rome and *Angels & Demons*, St. Peter's Square and Basilica, and the pope who holds the Keys of Peter. The angel Gabriel appears to Zachary (Zechariah) to announce the birth of a son and that son, John the Baptist, will herald the coming of Jesus Christ.

The Bible has for centuries interested scholars, and the novel's final pages remind us of the work of Francis Bacon, Isaac Newton, Benjamin Franklin, and Thomas Jefferson, not only the author of the Declaration of Independence, but also of the Jefferson Bible which sought to

Masonic Bible

find common ground and eliminate the "supernatural aspects" and "miracles" of Christ.

This all brings us back to the opening quote from *The Secret Teachings*. Mal'akh believes: *"The secret is how to die."* The phrase is repeated twice more for the symbolic three of religious incantations—the trinity. In fact, the secret is not so much how to die, but how to transcend

death. In John 11:25, we read, "Jesus said unto her, I am the resurrection, and the life: he that believeth in me, though he were dead, yet shall he live." The miracle of the healing of Lazarus is for Christians the clearest indication that death is but a beginning, a portal into eternal life. *The Apotheosis* is seen as symbolic, not of the resurrection of Christ, but the ascending into the heavens of a mortal man, George Washington, to be at one with the gods.

The final pages of the novel attempt to tie everything together. The Ancient Mysteries and the Bible are the same thing. (491). All unite in *"The circumpunct. The symbol of the Source. The origin of all things"* (459). The symbol of One Holy God. "E PLURIBUS UNUM. *Out of many, one"* (505). The novel, its characters, and we readers have all been on a path leading to transformation and illumination, the enlightenment of the human mind. The resolution or revelation is one that elevates the human mind above all else. *The Lost Symbol* is a new attempt to follow in the footsteps of the ancients and wise men through history to reconcile science and religion in the mind (our temple) and at the same time to reunite the mind and the soul for the attainment of at-one-ment. "God was the symbol we all shared . . . the symbol of all the mysteries of life that we could not understand. The ancients had praised God as a symbol of our limitless human potential, but the ancient symbol had been lost over time. Until now" (509).

All great truths are simple (459).

Links:

JEFFERSON BIBLE
www.angelfire.com/co/JeffersonBible

THE BIBLE
www.bible.com

Sources and Resources

> ⊓◻∟ ⊏∨ >∨ <⊐ ⊔⊏ ∟

Ever since I read *The Da Vinci Code* I have been intrigued by the "facts" that Dan Brown presents in his works. After reading his earlier works, I decided to offer a course at Middlebury College for first year students, designed to introduce them to the work of a scholar and the life of the mind via Dan Brown's "facts." History shows that some works of fiction have been misunderstood, misconstrued, and, in a few instances, misused (perhaps most notoriously *The Protocols of the Elders of Zion*). I believe that one challenge of education in the twenty-first century will be to make sense of the flood of information, much of it on the Internet, and to separate fact from fiction. Brown's novel offered a tantalizing and entertaining entry into the world of research and evaluating information. In the fall of 2004 students in my course, inspired by Betsy Eble's *Depth and Details—A Reader's Guide to Dan Brown's The Da Vinci Code,* prepared and edited a site intended to explore and explain all those aspects of the novel and published electronically, *The Keys to The Da Vinci Code.*

In the spring of 2005 I began along with a few others to anticipate Dan Brown's next novel. Long before the actual announcement of the September 15, 2009 publication date, speculation among a handful of writers and

researchers centered on a few hints. The inside dustcover commentary for *The Da Vinci Code* (2003) contained a series of letters in bold that when pieced together read: "Is there no help for the widow's son." That expression has been identified as a distress call used by Freemasons and was also the subject of 1973 talk by Dr. Reed C. Durham, Jr., claiming that Joseph Smith, the founding father of the Latter Day Saint Movement (Mormons), tried to utter this cry for help just before he was murdered. [www.cephasministry.com/mormon_is_there_no_help.html]

Brown himself stated on one occasion that he was working on another novel involving his hero, Robert Langdon, that would be "set deep inside . . . the enigmatic brotherhood of the Masons." (The quote, an answer to a question, was on the original danbrown.com page that has since been removed.) The working title, *The Solomon Key*, emerged in 2004: "the title, which will be *The Solomon Key,* a nugget Mr. Brown's publisher, Stephen Rubin, let slip during a lunch yesterday with reporters who cover the book industry"[www.nytimes.com/2004/10/28/books/28brow.html]. This title found its way into several books that attempted to predict the contents of the forthcoming novel, originally expected in 2005.

Hoping to have another subject for a course, I too began reading the available literature. There were three noteworthy efforts. First there was W. Frederick Zimmerman's *"The Solomon Key" and Beyond: Digital Fortress, Angels & Demons, Deception Point, The Da Vinci Code, and more . . .* (2005). Zimmerman's book, as the title indicates, looked back more than forward.

David A. Shugarts and Dan Burstein published *Secrets of the Widow's Son: The Mysteries Surrounding the Sequel to The Da Vinci Code* (2005). Burstein had already

edited a highly successful *Secrets of the Code: The Unauthorized Guide to the Mysteries Behind The Da Vinci Code* (2004) and *Secrets of Angels & Demons: The Unauthorized Guide to the Bestselling Novel*, later reprinted as *Inside Angels & Demons*. David Shugarts was a contributor to both, and he specializes in closely documenting "facts" and revealing the fiction behind them. In the book *Secrets of the Widows Son*, Shugarts examined the Masons and connections with "The Founding Fathers," the physical geography of Washington, D.C., the history of its construction as the country's capital, and the codes and ciphers that abound in Brown's novels.

Finally there was a tripartite effort by Greg Taylor, who reinvented titles, if not content, based on the supposed title of the novel. His first book was entitled *Da Vinci in America; Unlocking the Secrets of Dan Brown's Solomon Key* (2004). This was renamed as simply *The Guide to Dan Brown's The Solomon Key* (2005). Most recently it emerged as an electronic book as *The Guide to Dan Brown's The Lost Symbol* (Kindle Edition, 2009). Taylor has by far devoted more time and energy than anyone to *The Solomon Key* a.k.a *The Lost Symbol* for the past five years. He maintains an active web presence both at www.daily grail.com and at www.cryptex.com.

One of the more recent followers of the Brown phenomenon and one of the best analyses has been done by Mark E. Koltko-Rivera, author of *Freemasonry: An Introduction* (2007). In the beginning stages of "tweets," clues on Twitter that mirrored those on Facebook containing ciphers, clues, and images in search of decoding, Koltko-Rivera offered serious, thoughtful, and well-documented solutions to several dozen. Then he reconsidered and on July 13, 2009, concerned that others might use or appropriate his research, he stopped posting to Twitter. Recently he

171

has reappeared in a blog that comments not on everything but on much. His answers are well worth a visit: lostsymbol-tweets.blogspot.com.

Based on some of my own early research I traveled to Washington, D.C., on several occasions for the past four years to do work in the Library of Congress, visit the Capitol and the Washington Monument, and the House of the Temple in Washington, as well as the George Washington Masonic Memorial in Alexandria. I was treated to wonderful personal tours and immersed myself in the writings about Freemasonry. I also did extensive study of the literature surrounding the founding of Washington, Masonic imagery, the Mormons, the works of Sir Francis Bacon, Manly Hall, Albert Pike, and dozens of others.

In the fall of 2006, assuming the novel would be done, I offered a course on "The Solomon Key." Unfortunately Dan Brown did not produce, and there was no novel. But previous cues and my own research led students to do serious work on several themes that are relevant to the novel today. These were published on the Internet as *The Keys to The Solomon Key* and covered topics such as The Egyptian Influence in Washington, D.C., Masonic symbols in Washington, D.C., Benjamin Franklin, Francis Bacon, and Thomas Jefferson. Currently I am teaching a seminar on *Angels & Demons,* in which students are annotating the novel as a wiki.

Like others who have followed this novel closely, I was delighted to read the prepublication announcement and have participated in the Facebook and Twitter clue searches. I read the novel immediately along with my students, to whom I am grateful for identifying many of the keys that have become a part of my book. They raised many questions that deserved closer examination and, in the case of the dustcover, detected some names and numbers that helped

unveil some of the novel's keys. I also began an online guide to the novel, which I hope return to.

This book has been in the making for four years. I have devoured much of the literature on topics predicted, such as Masonry and Washington, D.C. I have explored the Internet extensively, visiting literally thousands of sites. Like almost all those who have been surprised in part, I have spent time acquainting myself with Noetics, *The Intuition Experiment,* and the Smithsonian Museum Support Center.

I am a scholar, but this is not a scholarly book. It is intended for the general reader who wishes to know something more about the topics and issues raised in *The Lost Symbol*. I have noted in my pages some of the books and authors that have been most helpful to me. I have also provided *133* Internet links that the readers can follow for additional information on each of the *33 Keys*. I have specifically not filled the work with the scholarly citation that would include all the books, articles, and Internet sites I have consulted. Nor have I routinely cited some electronic sources for quick reference that anyone would normally consult. These include search engines, *The Oxford English Dictionary*, the *Encyclopedia Britannica*, including the 1911 edition, *The Catholic Encyclopedia*, the *Internet Sacred Text Archive,* and *Wikipedia* and *YouTube*. Remember that "'Google' is not a synonym for 'research'" (98). But it sure is a great place to start.

This book would never have appeared were it not for Grace Freedson, who kept looking for someone to find it. Esther Margolis of Newmarket Press believed and inspired me to believe that it could be done in time to satisfy readers already searching for answers. Her staff has worked miracles to design and illustrate these *33 Keys*. My students never doubted and their reading of the novel, their own search for Ancient Wisdom, supported my efforts. Finally, my lovely

wife Dorothea, my gift from God, Carina, my beloved, Stefanie, my crown, and Alexandra, my defender, all endured and sustained my efforts and found their way into the square of the dedication.

To my readers I extend my hand in invitation to share your comments and suggestions at tom.beyer@middlebury.edu.

Links:
THE KEYS TO THE DA VINCI CODE
community.middlebury.edu/~beyer/dvc

THE KEYS TO THE SOLOMON KEY
community.middlebury.edu/~beyer/sk/index.htm

THE KEYS TO ANGELS & DEMONS
keysangelsdemons.wetpaint.com

KEYS TO THE LOST SYMBOL
keystolostsymbol.wetpaint.com

POSTERS, LOGOS, AND MORE ON *THE LOST SYMBOL*
knopfdoubleday.com/tag/the-lost-symbol

About the Author

Thomas R. Beyer, Jr., a Professor at Middlebury College, who specializes in Russian language and literature, has taught numerous seminars on the works of Dan Brown, and is the editor of the online reference guide *The Keys to The Da Vinci Code.* He and his students are currently working on a wiki devoted to *Angels & Demons.* He began working on *33 Keys to Unlocking The Lost Symbol* three years ago. He is based in Middlebury, Vermont.